1992: ABOUT APERTURE

Forty years after its origination, Aperture *celebrates the founders' affirming spirit. Seventy photographers published in* Aperture *since 1952 selected three photographs especially for this anniversary issue. One image from each artist was chosen. The photographers also wrote their thoughts on photography in general or, if they preferred, about their work in particular, much as the founders suggested should happen in their first editorial.*

To those individuals who congratulated us, we thank you for your gracious words—although as you know, we chose not to print them here. To those photographers who could not participate this time, perhaps at the next milestone. As for the hundreds of photographers we have published in the magazine over the years but were not able to include, we thank you for your past collaboration and look forward to working with you in the future. And then there are all the wonderful photographers we've yet to publish—here's to the next forty years!

The process of bringing together a "forty years" celebration forces one to see photographs as, among other things, indicators of their time. Several photographers address AIDS in their text or images; the brutality of this devastating epidemic became all the more jolting when David Wojnarowicz died of AIDS during the preparation of this issue, having selected his photograph, but without having had the time to write his text.

Whereas images cannot directly combat the overwhelming reality of such tragedies, history—recent and distant—has proven how powerful photographs are in revealing injustices, insisting upon action, and inspiring controversy and, often, change. In keeping with the spirit of Dorothea Lange and other founders

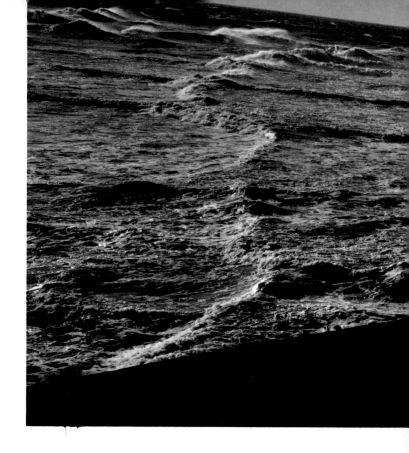

who measured Aperture's *success in part by the depth and expression of its social conscience,* Aperture *will continue to be a forum for those photographers who are committed to confronting the crises and concerns of our time.*

It would not have been possible to put together such a representative and meaningful issue without the extraordinary insight, talent, perceptions, and creativity of Aperture's *past editors. To Minor White (in spirit), Jonathan Green, Carole Kismaric, Lawrence Frascella, Mark Holborn, Nan Richardson, and Charles Hagen, we extend our deepest appreciation and admiration.*

We are especially grateful to Robert Adams, who interviewed Michael E. Hoffman, Aperture's *publisher and editor since the 1960s. Sequestered away for a weekend by the Columbia River, Adams questioned Hoffman first about* Aperture's *early days, looking at his association with Minor White, Paul and Hazel Strand, and many others, and then focused the conversation on* Aperture's *evolution, its more controversial issues, and its future.*

We are equally indebted to Robert Rauschenberg for so generously making the first-ever specially created cover of Aperture. *Since no single image could serve to represent the last forty years, we looked to Rauschenberg—knowing that among his extraordinary talents he is a superlative collagist—to create a cover*

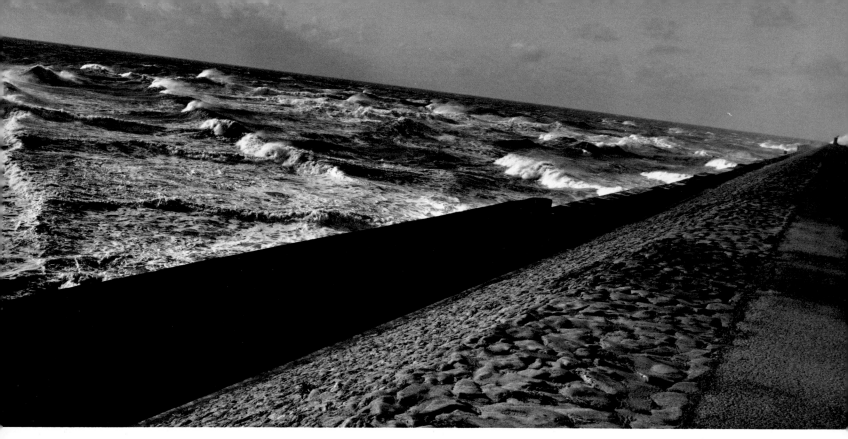

JOSEF KOUDELKA *Boulogne sur Mer, 1988*

that would visually and metaphorically give a sense of Aperture.

Orchestrating often disparate images, Rauschenberg discovers juxtapositions and interrelations that defy preconceptions and a linear reading. The wheel and horse on this cover, recurrent images in Rauschenberg's work, might signify movement in different directions, by different means, over time. Yet, the liberating quality of Rauschenberg's work is found in the multiplicity of experiences it presents to the viewer. In the following pages and, we hope, in the following years, Aperture *will offer many ideas, meanings, directions, interpretations, perspectives, voices, visions, and happy accidents, opening here with the timeless, regenerative waves of Josef Koudelka.*

Join us in celebration and in exploration, and thank you for being a part of the Aperture *community.*

THE EDITORS

Number One Hundred Twenty-Nine, Fall 1992

4

RAY K. METZKER
From the series "Sojourn in the South of France," Fall 1989 (*opposite*)

Work is methodical; the creative process is not. Why one picture stands out among many others is always a mystery. In the beginning the subject is never quite known, but in the course of working something shows up on the film or in the print that speaks to me. I can never predict when this will happen. However, when it does there is an excitement—there is the ecstasy of recognition. And this is one of the things that keeps me going.

ALLEN GINSBERG *William S. Burroughs*, 1991

For forty-five years I've been taking snapshots of friends I've felt an affinity with, venerated—soul mates, men and women I've grown up with since I was nineteen, attached to my idea of them as lifelong companions. William S. Burroughs has been one of the steadiest personages magnetizing my attention (among poet-friends, family, odd acquaintances). First photos of him begin in 1945, continue episodically through decades, including this one. In spring 1991, I stayed in his house, helped prepare breakfast, talked, browsed and gossiped for a week, took out my camera on occasion when I noticed some characteristic posture or activity, fed his six cats, mealtimes with supermarket tabloids on the table, bent over worktable painting in his studio. He didn't pay particular attention to the camera; nor did I, except when framing photos—which I did often.

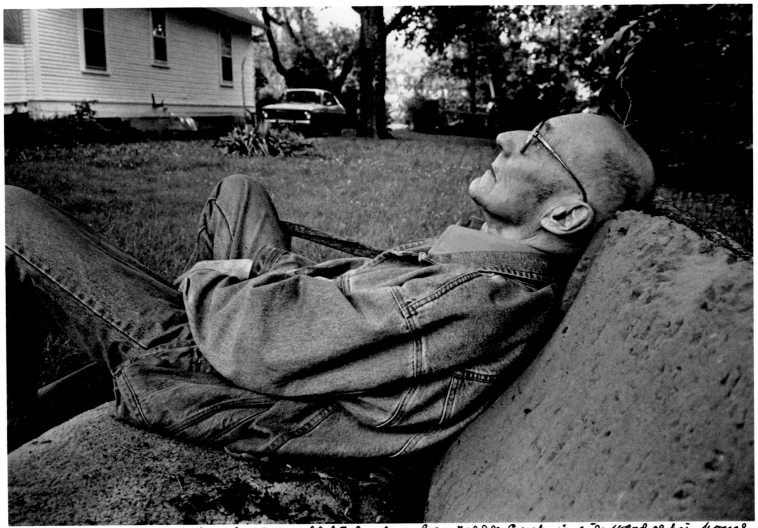

William Seward Burroughs relaxing on old brokendown foam rubber couch in side yard of his house, looking through treetops to the sky, Lawrence Kansas May 28, 1991.
Allen Ginsberg

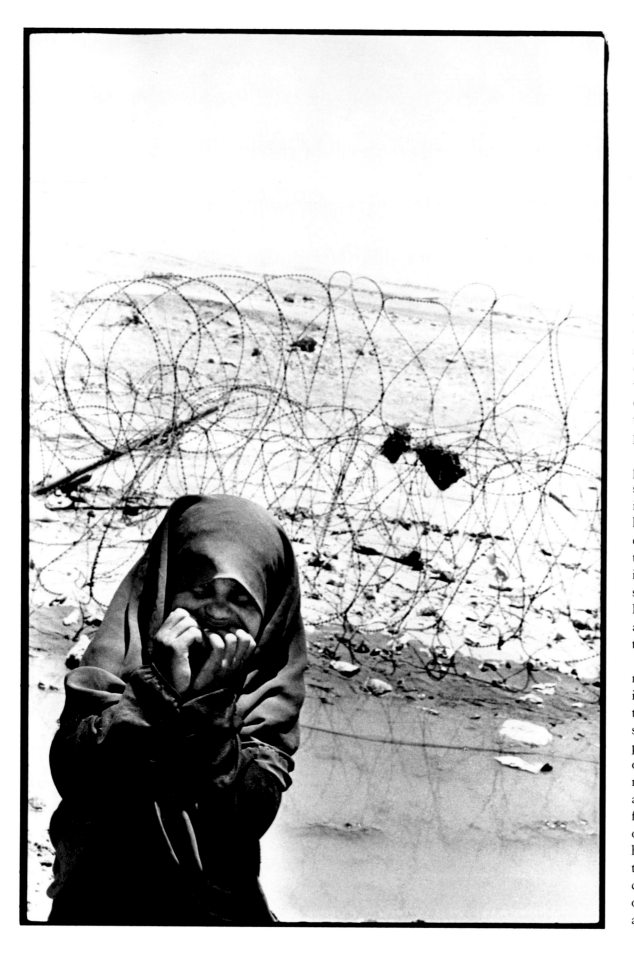

SYLVIA PLACHY
Rafha Refugee Center,
Saudi Arabia, 1991

In May 1991 we were flown into a refugee camp in the Saudi desert twenty kilometers from Rafha. It was an official tour for United Nations observers and journalists, sponsored by the Saudi military to show us Iraqis who had fled Saddam Hussein's terror. We were greeted by men, residents of the camp, who looked at us as though we had the power to deliver them from this vast emptiness. In a place without walls, and in an attempt to communicate, ten stood outside the tents holding up drawings of war and suffering, while in the scorching heat others had in their hands their treasured clear water in sealed plastic bags.

Suddenly I saw a little girl, prematurely veiled, running and stopping in turn: a black flame in a blinding desert. I followed her. She turned and quickly covered her mouth. Perhaps it was a timid smile she was hiding, but in her frail, shrouded figure, I saw Edward Munch's *The Scream*. I stooped to take her picture, and the barbed wire surrounding the camp rose behind her.

As a relentless gatherer of moments, I find that my favorite images, although grounded in the present, are like spirits shaped by memories. They whisper of fairy tales, poetry, and other lives, as each gesture connects with another and raises yet another from the dead. Shadows flicker on film to an inner melody as I navigate, camera in hand and at the speed of light, through unimaginable worlds—desperately trying to make sense of the joy and suffering before it all disappears.

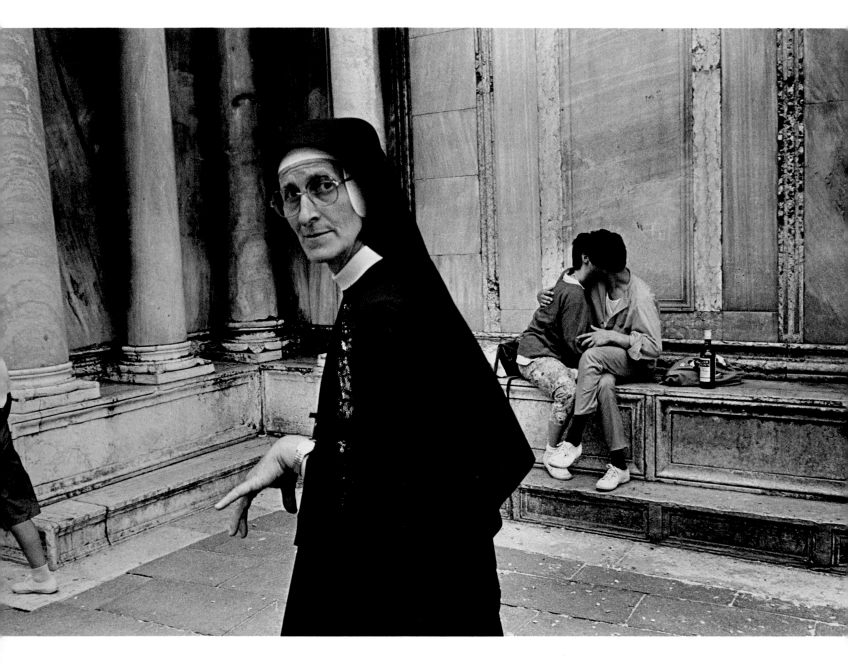

DONNA FERRATO *Nun in Venice*, 1986

As a photographer I'm interested in living and looking. I look in order to learn and I live for the pleasure of discovering things. For me it's important that the ear and the brain be involved as well as the eye. Not for me is that uninvolved wanderer with a camera—some invisible alien, coldly holding a tin box without a heart. My camera has feelings.

Feelings of curiosity pull me along the path of adventure and discovery; I explore with the credo that it is safe to go anywhere as long as the small, quiet, simply constructed box is nestled under my arm. Time has made the camera a wise friend, clever at catching hold of the things I see that are intriguing or disturbing.

After years of taking pictures and recording testimonies, it was ultimately the struggle of making a book that helped give me purpose and focus as a photographer.

I explore with the credo that it is safe to go anywhere as long as the small, quiet, simply constructed box is nestled under my arm.

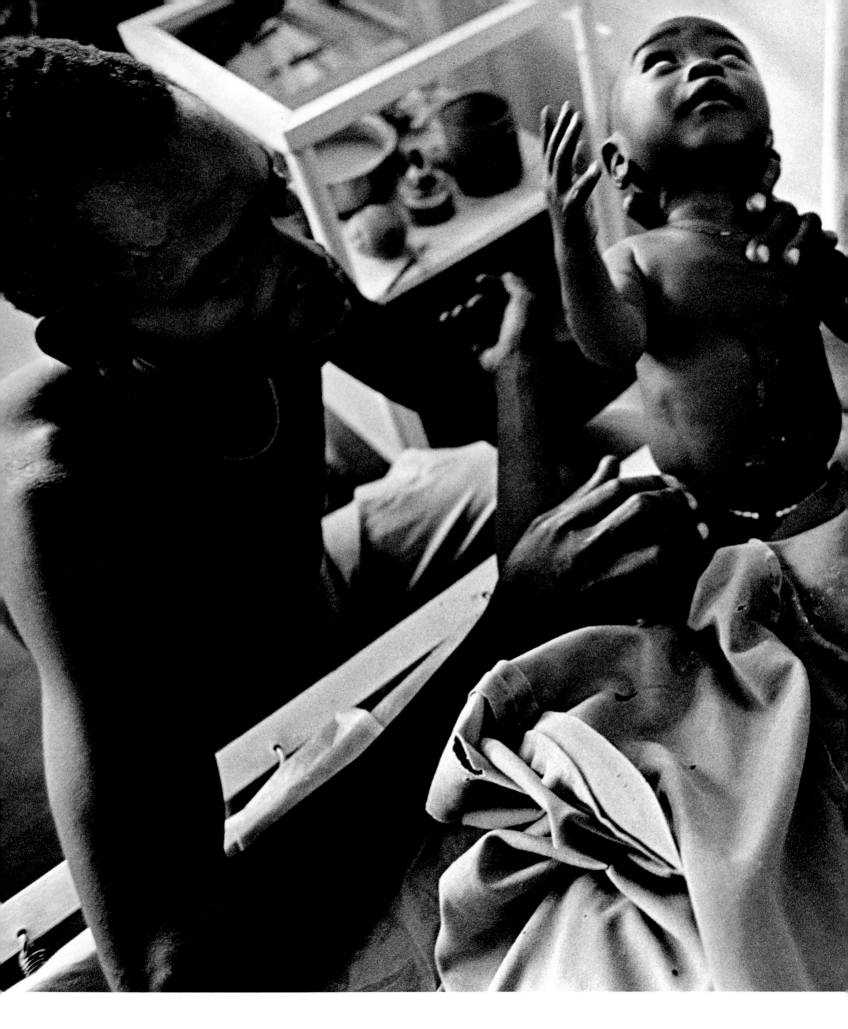

EUGENE RICHARDS
Family, Moyo Hospital,
Uganda, 1991

I'm sure everyone's heard a version of this before—the old saw that with age and experience comes a certain disillusionment. I chose to be a photographer twenty-two years ago, but I don't know if I'd make that choice again. Back in the early eighties, I still thought I was doing okay, trying to order and shape the world with my camera. Now that I know a bit more about living and dying, about our planet and its complex problems, I'm a lot less comfortable with my images of people.

Still, I haven't a clue what else to do. So I keep on, sometimes arguing too much with editors, still working when I

With a few exceptions, those of us working as photojournalists might now more appropriately call ourselves illustrators.

can as a photojournalist. Photojournalist? With a few exceptions, those of us working as photojournalists might now more appropriately call ourselves illustrators. For, unlike real reporters, whose job it is to document what's going down, most of us go out in the world expecting to give form to the magazine, or to newspaper editors' ideas, using what's become over the years a pretty standardized visual language. So we search for what is instantly recognizable, supportive of the text, easiest to digest, or most marketable—more mundane realities be damned. This is true even of many of the photojournalists who attend to what Cartier-Bresson once termed "the tragedies." Because, given a choice, few editors would choose to have sickly or antagonistic laborers, drug addicts, or hungry people staring up at readers, when traditional and far less troubling pictures of passive and proud poor people can be bought.

9

BEAUMONT NEWHALL
Nancy Newhall, New York City, 1946

In September 1951 about forty photographers, artists, and other people interested in photography met for ten days at the first photographic conference of the Aspen Institute of Humanistic Studies.

The panel of speakers consisted of photographers: Berenice Abbott, Ansel Adams, Ferenc Berko, Will Connell, Laura Gilpin, Fritz Kaeser II, Dorothea Lange, Wayne Miller, Eliot Porter, Minor White, as well as John Morris of the *Ladies Home Journal*, Paul Vanderbilt of the Library of Congress, and myself of the George Eastman House. We each had a talk and led discussions. There were enthusiastic and lively conversations on all aspects of photography, and daily photographic field trips around the local area led by one of the photographers.

Ansel, in his talk, called for the establishment of a "dignified" professional publication of photography. We discussed this informally quite a bit. We felt we very much needed a periodical in which we could talk about photography and learn from one another.

Later, at Ansel and Virginia's house in San Francisco, nine of us met and officially founded *Aperture* magazine. There was much discussion as to what to call the magazine. Ansel suggested the title *Aperture*, which was accepted, and Minor volunteered to be its editor.

We had met Minor earlier, in 1945, just after he had returned from military duty in the Philippines during World War II. We knew his excellent photographs and had purchased a number of them for the department of photography at the Museum of Modern Art, where I was curator at the time. I was delighted when Minor called on me at the museum one day. He was on his way to Columbia University to study with the brilliant art historian Meyer Shapiro. I hired Minor as an assistant at the museum.

Later, in San Francisco, Ansel was building darkrooms in preparation for teaching at the Department of Photography (which he had founded) at the California School of Fine Arts. He needed an assistant, so we suggested that he invite Minor to come and work at the school with him. He was teaching there at the time of the Aspen conference.

In 1953 Minor left the California School of Fine Arts when they limited their program in photography. At that point I invited Minor to join us in Rochester and work as my assistant director at the George Eastman House. He became editor of the museum bulletin, *Image*, and also arranged exhibitions. He also taught photography as a fine art at the Rochester Institute of Technology one day a week. So Minor was very much occupied with these jobs at the same time that he was editing and publishing *Aperture*.

What I said in 1970 still holds true today:

Aperture is without question the most significant periodical concerned with creative photography. To go through the files of this quarterly is to trace the development of the art of photography during (four) formative decades. A remarkable standard has been maintained in the quality of reproductions, in typography, and in literary content. Of particular importance is the emphasis which is placed upon the aesthetic examination of the medium of photography. . . . *Aperture* serves as a vehicle for the better understanding of the most vital expression of our time.

EUDORA WELTY
Storekeeper, 1935

What enabled me to photograph in the 1930s and 1940s was the familiarity of the world I was in, and the openness between people at that time, and my being just plain ignorant of how to do any of it, so ignorant that I didn't know not to try. All of it was so spontaneous and so simple that I didn't even have to think about it. If I'd known how little I knew, I would have been paralyzed.

Everything was comfortable and easy. It wasn't until later, when I would think back, that I felt that I must have intruded on people; and yet I didn't feel that at the time. I didn't feel intrusive, and I don't think they felt I was. It's the same way that you learn about writing, I think, when you teach yourself, as I did in both cases. They taught me. The subjects taught me, and my response was what I photographed.

It's a matter of discovering a relationship, too, a human relationship. You can go back and try to analyze what it amounted to, but at the time you don't do anything like that. It is just spontaneous and trusting.

I'm not very eloquent about things like this, but I think that writing and photography go together. I don't mean that they are related arts, because they're not. But the person doing it, I think, learns from both things about accuracy of the eye, about observation, and about sympathy toward what is in front of you. It's about trying to see into the essence of reality. It's about honesty, or truth telling, and a way to find it in yourself, how to need it and learn from it.

I still go back to a paragraph of mine from *One Time, One Place* as the best expression I was ever able to manage about what I did or was trying to do in both fields. It's still the truth:

I learned quickly enough when to click the shutter, but what I was becoming aware of more slowly was a story-writer's truth: The thing to wait on, to reach for, is the moment in which people reveal themselves. . . . I learned from my own pictures, one by one, and had to; for I think we are the breakers of our own hearts.

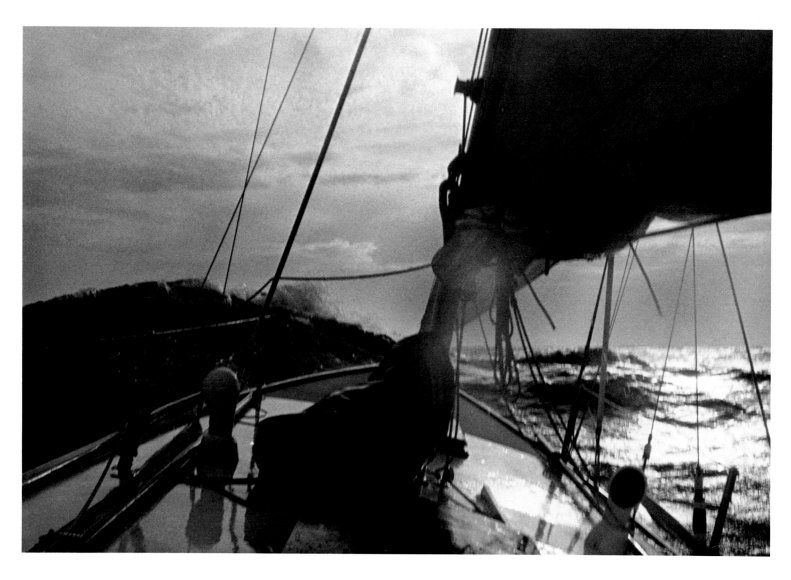

JOHN McWILLIAMS
Diary entry, June 7, 1991:

In the morning we left Bermuda on a fresh southwest breeze. The day was cloudy, but with expectations of the wind holding up, we could make distance from the island. About mid morning we heard a weather report that said there would be a renewed gale from the southwest. As the wind increased it became apparent that we needed to get away from the island as quickly as possible, and this meant going southeast toward Africa. For the rest of the day we proceeded away from the island to get the relative safety of sea room. All day the wind increased. By late evening we had made our sea room, so wearily we hoisted storm sails and hove-to to wait out the gale below. It was a forboding night of high seas and wailing wind. We each took turns watching for shipping. As it was, there was quite a bit. On a stormy night such as this the presence of shipping gives no comfort.

DAIDO MORIYAMA
Water Flower, 1988 (*opposite*)

Photographs are pieces of the everlasting world—daily life—and fossils of light and time. They are also fragments of presentiment, inspiration, record, and memory about human beings and their history, as well as another language and world that becomes visible and intelligible through objectifying reality by means of cameras. They show us beauty and tenderness and also ugliness and cruelty now and then, not as the answer but always as a new question. I believe photographs to be pieces of an incomplete jigsaw puzzle. Which is why I have been and will be devoted to photography.

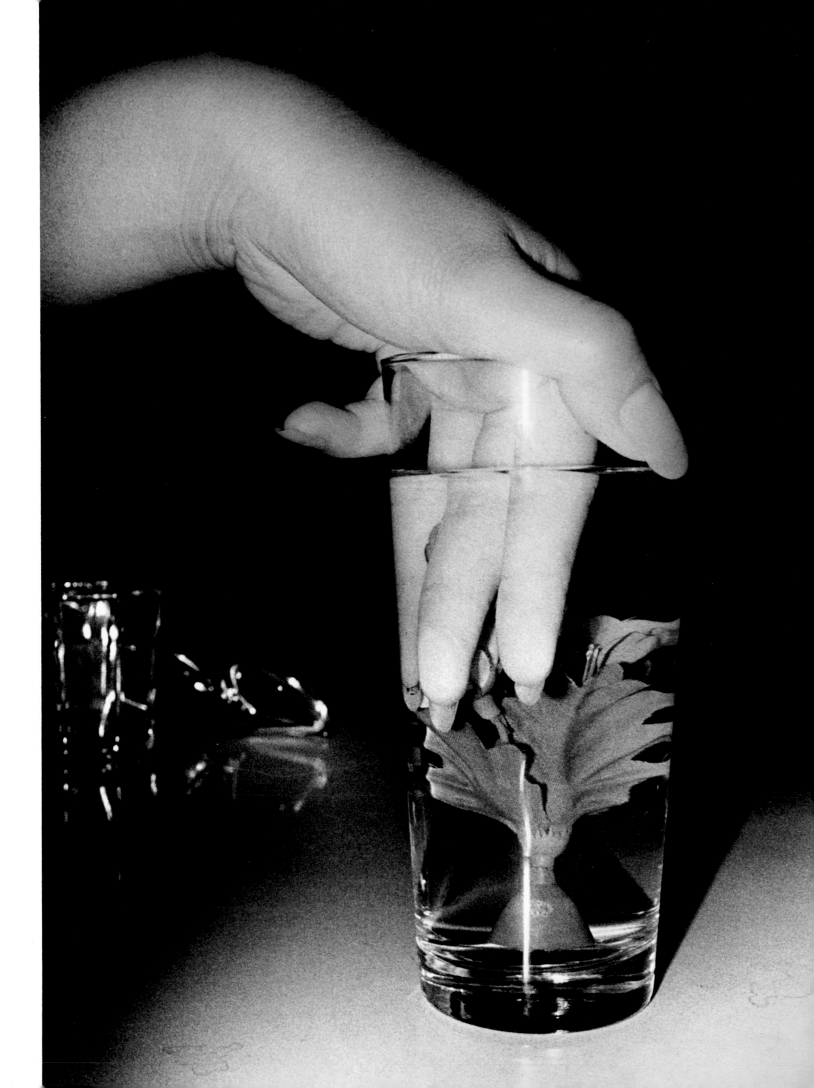

LARRY FINK *Wedding*, New York City, 1991

I've been photographing weddings for a long time; it's not a specific project, it's part of the major project. Throughout my life I've been involved in being in and looking at rituals emboldened by power, choice, and illusion.

The last wedding I photographed was actually very good-spirited, rather joyous. It was the world of high fashion—all the superstar models, the look of sensuality. I had the impression that their narcissism and exhibitionism were shared on a deep, physical level: as if they existed within a perceptual membrane, surrounded by the skin of self, licensed by illusion.

Human honesty and deception have been the core of my work. I am drawn to energy that is both constrained and unbounded, and I try with the camera to fix the complexity of the moment: to create an infectious perception, so as to change the viewers' aloof judgment to one of unavoidable, impassioned involvement.

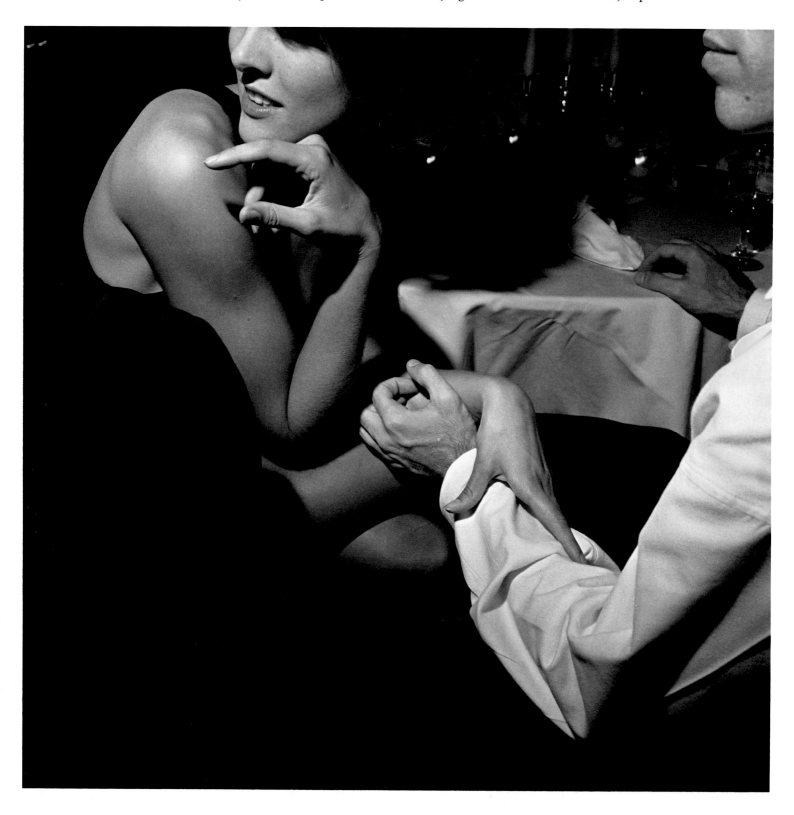

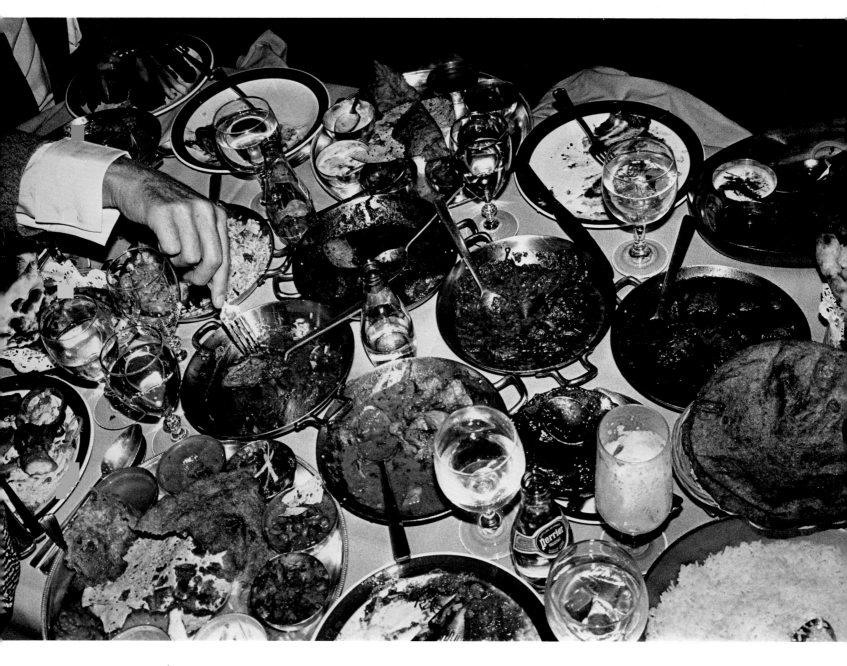

JEAN PIGOZZI *Thanksgiving Dinner in a New York Indian Restaurant*, 1988

I love taking photographs. The moment when I press the shutter is fantastic, orgasmic, so charged with the hope that this will be a great, original, interesting, and perfectly composed photo. But like any other exciting thing in life, it is usually spoiled by some ridiculous, unpredictable, and annoying detail.

My situation is diametrically opposed to that of the painter with his disciplined model. My subject, to whom I owe everything, usually has an uncontrollable mind of his own. I am his slave. I must wait for that special expression, that bizarre leg movement, that odd moment when the subject looks relaxed yet

still full of life (or when that idiot with the ponytail and the brand-new Che Guevara T-shirt will disappear from the background and stop screwing up my masterpiece).

I take pictures of everything from Kleenex boxes in the back of Rolls Royces to dogs to real geniuses like Andy Warhol, who taught me more about looking at this funny world than anyone else. I keep observing the world in the hope that more of those rare, incredible, and magical moments will enter my camera. For this I have been willing to look like a giant Japanese tourist, carrying my Leica around my neck and photographing everything around me during the last twenty-five years of my visit to this planet.

My subject . . . has an uncontrollable mind of his own. I am his slave.

SOPHIE CALLE
Untitled, from the series
"The Graves," 1991

I traveled for seven years, and when I came back home I was completely lost. I didn't know what to do with my life, so I decided to let people decide for me. For months I followed strangers on the street. For the pleasure of following, not because the party interested me. I photographed them without their knowledge, took note of their movements, and finally lost sight of them. At the end of January 1980, I chose a man and followed him to Venice. That's how I started. That's all.

**MESSRS. DAVID MCDERMOTT
AND PETER MCGOUGH**
Melancholy the 5th December, 1915, 1991

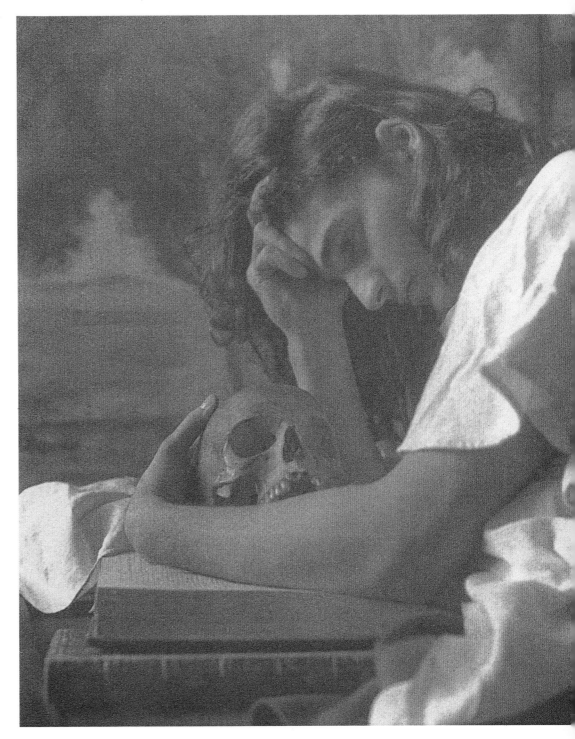

There are numerous Photographic Processes that were both originated and abandoned in the Nineteenth and early Twentieth Centuries. Instead of exacting any possible creative idea from the relatively small range of contemporary Photographic Developmental Processes that may still remain unnoticed by the

*The Artist has the
Confidence to know that no
interest of his is futile . . .*

greater, ever-growing Photographing Public, the Artist seeks inspiration where the layman is not. Of course, many Photographers await the newest gadgetry or chemistry with the hope of making a name for their prescient genius before the crowd likewise follows suit, but an individualist is often absorbed with the debris of what that very crowd has left behind. The Artist has the time to investigate. The Artist has the Confidence to know that no interest of his is futile, for Art can be born in a manner that is compatable with its Predestined Pedestal. The Degraded Past remains the surest Source for the Uncertain Future. The One Hundred Famous Photographic Processes of the Turn of the Century are an Enigma to the Million Photographers who, desperate for recognition, are unprepared for discovery. Their abuse of Photographic Technology can be likened to a narcotic Dependence, with the Manufacturers of Film and Electric Bulbs acting as Hop Merchant.

The Artistic media of painting and drawing allow for creation without the precedent of a changed reality. In other words, the Fantasy of an Ideal in Canvas or Sculpture is not dependent on that Ideal in the material sense before it may be rendered artistically. Whereas Photography, both still and moving, requires an existing or a manipulated reality. To photograph an Eighteenth-Century city requires the restoration or rebuilding of one, or at least the fabrication of the illusion of an Eighteenth-Century city. This example of changing reality to correspond with an artistic vision so that a product may be produced and marketed is an exciting proposition for the Artist. With the advent of Modernism and Minimal Aesthetics, the altering of reality to produce fantastic art has been generally confined to the commerciality of Moving Photo Plays. In the Past, great spectacles were constructed to entertain the Eye, so that the world became quite embellished with Man's achievements. It is worthy of notice that with Man's augmented Photographic Abilities his concern for the Environs of those Photographs have fallen far beneath the standards he sets for his Graven Images.

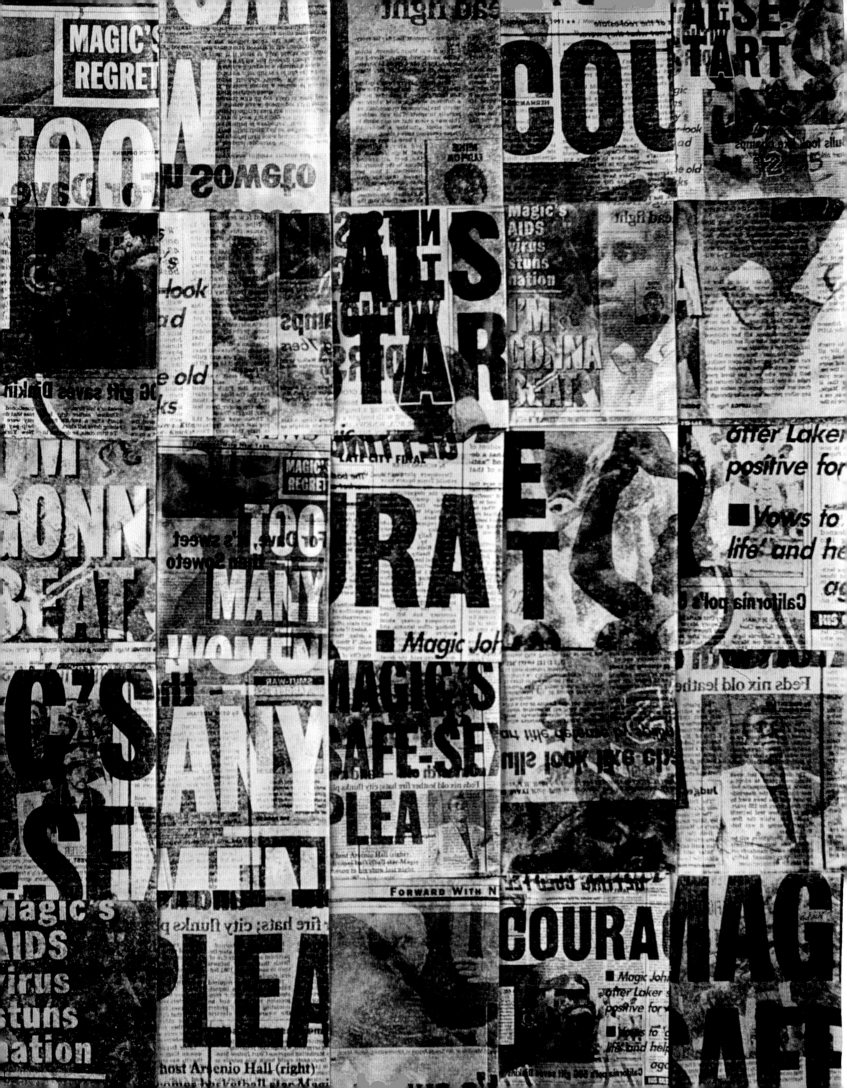

MICHAEL SPANO
Magic's Regret, 1991 (*opposite*)

"News" is an outgrowth of my previous photographic projects, all having the subject of the city as a unifying element. I am interested in describing the experience and complexity of urban life, as well as how our memory is forced to

I visually translate things that we remember or forget as we turn the bold front pages of newspapers. . . .

negate or decipher the continuous bombardment of information. In this series, I visually translate things that we remember or forget as we turn the bold front pages of newspapers, where aggressive typography competes for urbanites' attention.

All of the pieces in the "News" series are unique, toned, gelatin silver prints made from an array of 8 × 10-inch negatives and assembled in a grid pattern.

In this series, I deconstruct and reassemble headlines of city tabloids into metaphoric current-event puzzles, creating an abstracted logic out of the seemingly accidental layers of type and photographic fragments.

DOUG AND MIKE STARN
Extreme Convex Siamese Twins #1, 1990

The only way for the creative mind to function is through anarchy. Art can't flourish while bound to the concerns of previous generations. Photography, as a rule, has too many rules.

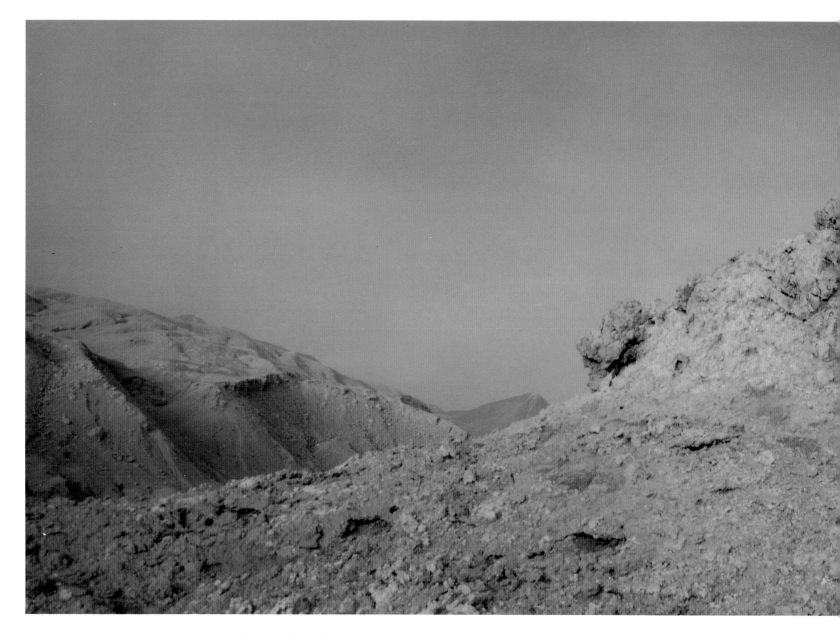

NICK WAPLINGTON *Chile—Valley of the Moon*, 1991
From the series "Circles of Civilization."

As we move toward the end of the millennium, things seem to be speeding up. The world is changing rapidly. And as I get older, I feel more rebellious. I'm twenty-six, and I want to make work that deals with my feelings about this historic point in time.

I got the idea for this project when I was living in Naples, and I was very cut off from the world. My Italian is appalling. But I had a short-wave radio, and it was the end of 1989—the Berlin Wall was coming down, the Soviet Union was falling apart, and economic pressures were coming to bear in Britain as well as in the U.S. The eighties boom period was over. I felt quite alone and quite strange, and my only connection with the world was listening to the world news. All these things were happening around me, and I thought, I've got to try to find a way of utilizing this in my work.

Photography is often about the past. My idea was to make pictures that deal with the future, not the past. I wanted them to have a timeless quality. So I have my head shaved whenever I'm

Photography is often about the past. My idea was to

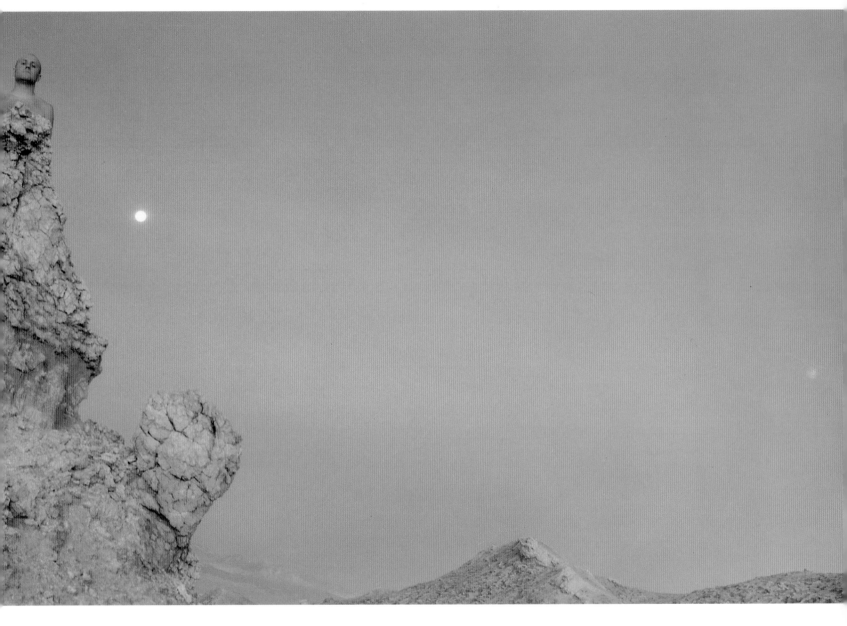

going to shoot—which I hate, but hairstyles date images to a specific time. You can almost always tell by people's hair when a picture was taken.

The camera that I use is the Pentax 617, which is the hobby camera of advertising photographers. It's the camera that they take on their holidays, and they produce these aesthetically beautiful landscapes. I wanted to produce harsh, almost grim pictures, because these cameras have only been used to make beautiful things. And whereas the last pictures from my "Living Room" series were very cluttered (and I wanted them cluttered),

the new images are empty and barren. I want these pictures to be dangerous. I'm not interested in producing beautiful photographs. My earlier work has a sort of a gritty resin to it, and I want these images to have some of that quality.

When I come to a new idea or a new project, I try to find ways of producing the work that best express the overall concept. I go out and I see what cameras are available, what types of film, and I try different ways of working. The photographers that I like are the ones who look at each thing they do with fresh eyes.

nake pictures that deal with the future, not the past.

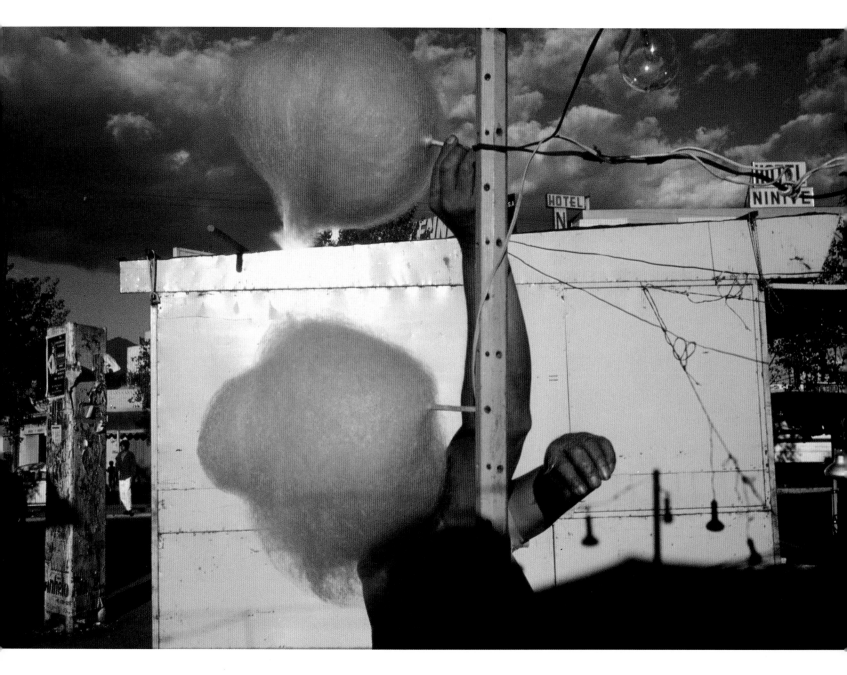

ALEX WEBB *Oaxaca, Mexico, 1991*

Robert Stone recently wrote of his early experience in Havana: "Walking out of the shadows of the covered wharf and into the bright sunlight of the street, I took my first step into that problematic otherness that would so tax our country's moral speculation: the un-American world." For the past fourteen years I have tried in some fashion to explore this "problematic otherness," photographing in the tropics in color, attempting to understand this other as well as examining—albeit very obliquely—the self. There is something about the light, the colors, the heat (physical and perhaps metaphysical), the vibrancy of street life, and the rawness and disjointedness of much of the tropical world that has moved and disturbed me—in places where the indigenous culture is often transformed by an external northern culture (sometimes my own). This obsession has led to various photographic projects: a kind of extended poetic meditation on the tropics in general, a much more sociopolitical exploration of Haiti in a key historical time, and an ongoing journey through the streets of Mexico. And this obsession has persisted. Even recently, as I have attempted to turn my camera northward and tried to photograph my own country again, I find I have been drawn, at least initially, to the Caribbean and Hispanic peoples of subtropical Florida, and how their world intersects that of leisure-class North America. I suspect that one only has a few serious creative obsessions in life. I certainly cannot seem to escape this one.

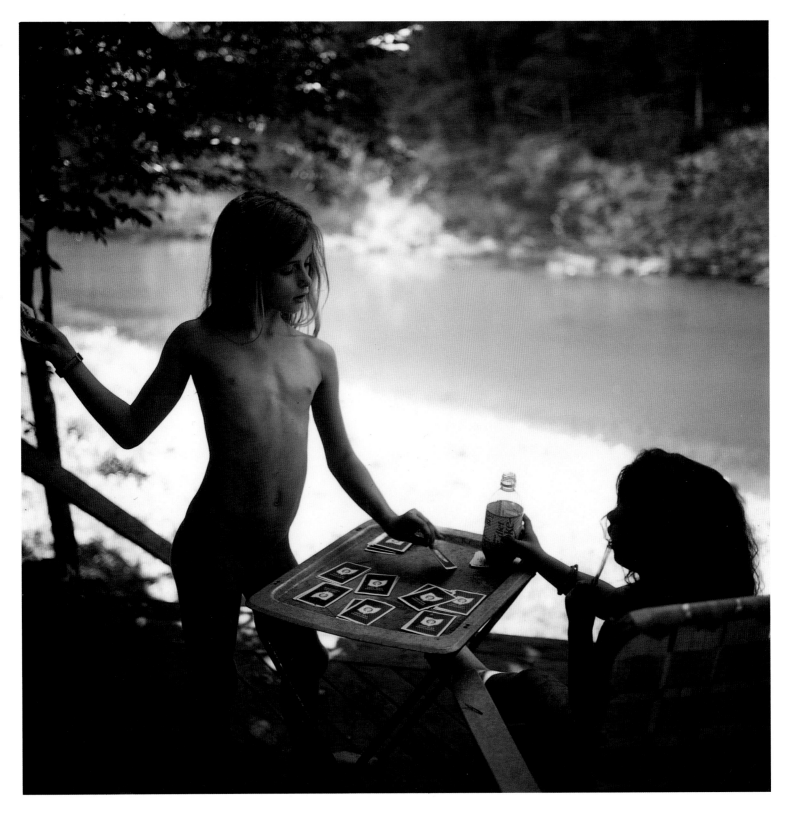

SALLY MANN *Untitled*, 1990–91

I keep trying to take better pictures. My approach is one of squinty-eyed doggedness. It would seem mechanical except for those ecstatic moments of luck that occasionally befall me. I am convinced that this persistence has played a far greater part in the making of my work than any special talent.

Sometimes, when I get a good picture, it feels like I have taken another nervous step up into increasingly rarefied air. Each good-news picture, no matter how hard-earned, allows me only a crumbling foothold on this steepening climb—an ascent whose milestones are fear and doubt.

But there are those pure, hot moments when the good ones happen. It's an epiphany so strong that, to my children's bewilderment, I have occasionally fallen to my knees in thanksgiving.

MAGGIE STEBER *Housing Project*, Miami, 1991

Photographs are like our children. We put the best of ourselves into them—the best of our vision, our minds, our hearts—and then we send them out into the world. At some moment, perhaps the moment we click the shutter, they are being released. From that moment on, they don't really belong to us anymore. We are defined by them but they cannot be defined by us. They are defined by the viewer and the viewer makes of them what he or she pleases, whether we like it or not.

Every time we click the shutter, it's like a new day, a new chance to make a clean start, to be original. It's a very exciting and exhausting thing to do. And I can never quite get over this feeling: that each time I take a picture, it's like seeing for the first time, but I mean really seeing, not just looking.

Russell Lee, who infused as much heart as anyone into the great chronicle produced by the Farm Security Administration during the Depression, taught that respect is the most important thing you put into your camera. It's like slicing off a little part of your heart and putting it in with the film. Go ahead and think me sentimental. I stand on some mountain somewhere and voices in the wind tell me this is the only way to live my life.

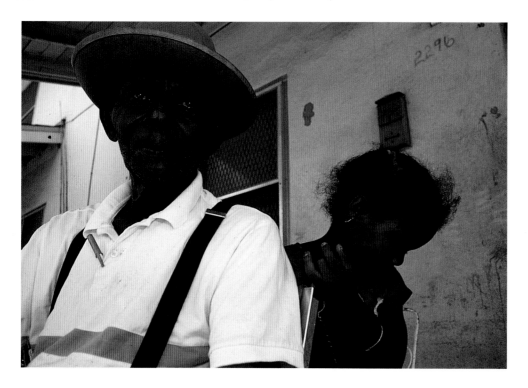

CHUCK CLOSE *Self-Portrait, Composite, Sixteen Parts*, 1987

The thing that interests me about photography, and why it's different from all the other media, is that it's the only medium in which there is even the possibility of an accidental masterpiece. You cannot make an accidental masterpiece if you're a painter or a sculptor. It's just not going to happen. Something will be wrong.

This is simultaneously photography's great advantage and its Achilles heel: it is the easiest medium in which to be com-

It always amazes me that just when I think that there's nothing left to do in photography . . . someone comes along and puts the medium to a new use, and makes it his or her own.

petent. Anybody can be a marginally capable photographer, but it takes a lot of work to learn to become even a competent painter. Now, having said that, I think that while photography is the easiest medium in which to be competent it is probably the hardest one in which to develop an idiosyncratic personal vision. It is the hardest medium in which to separate yourself from all those other people who are doing reasonably good stuff and to find a personal voice, your own vision, and to make something that is truly, memorably yours and not someone else's. A recognized signature style of photography is an incredibly difficult thing to achieve.

It always amazes me that just when I think that there's nothing left to do in photography and that all permutations and possibilities have been exhausted, someone comes along and puts the medium to a new use, and makes it his or her own, yanks it out of this kind of amateur status, and makes it as profound and as moving and as formally interesting as any other medium. It's like pushing something heavy uphill. Photography's not an easy medium. It is, finally, perhaps the hardest one of them all.

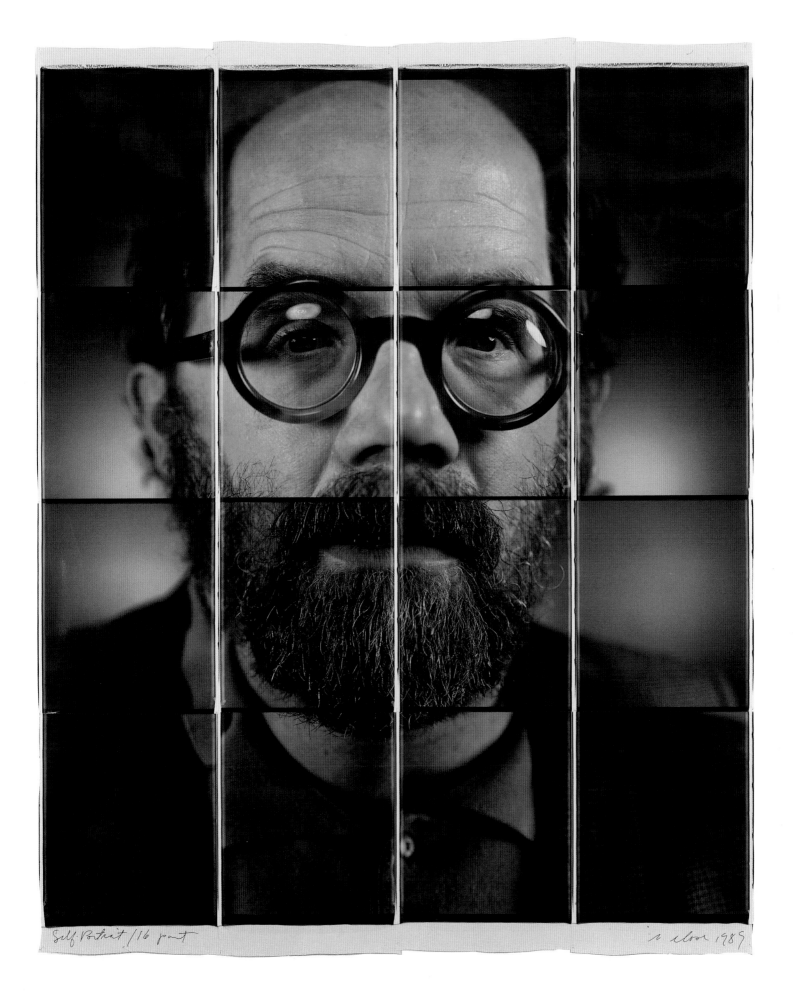

Self-Portrait / 16 part c close 1989

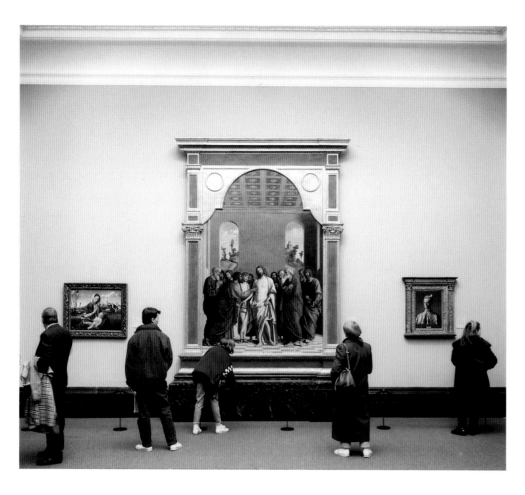

ALEX HARRIS
Abelino's Mother's House,
Las Vegas, New Mexico, 1984

Sofia lived in a small adobe house on a dusty back road across the tracks in Las Vegas. When I knocked on her door early one winter morning in 1984, Abelino was still getting dressed. He let me in, promised me coffee, and left me to wait in Sofia's pale-green living room. In one dark corner, a portable, black-and-white television glowed and squawked. Beneath it, Sofia had constructed a shrine out of the shell of the original family set.

Some company made that big television as a box for transmitting stories, and when the box was worn out, its stories were discarded and replaced by what

This photograph reveals a leap of faith, a creative human act to place religion at the heart of everyday life.

is perhaps the oldest story in the world: one woman's appeal to God and his saints to watch over her family, to keep them safe. Yet this same woman placed the ultimate, profane, twentieth-century plastic object right there on top of its sanctified wooden cousin.

This photograph reveals a leap of faith, a creative human act to place religion at the heart of everyday life. For me this picture also speaks to the luck and fate that twenty years ago led a young man with a camera into what seemed the altogether exotic world of Hispanic northern New Mexico. I lived in that world until my life somehow merged with the lives I photographed, until I became part of the story I am trying to tell. It is an image that extends an old adage, a photograph that declares how fundamental seeing is—not just for artists and photographers, but for all of us. *Seeing is believing.*

THOMAS STRUTH
National Gallery, London, 1989 (*above*)

For the past two or three years I have traveled around the world, in Europe, Japan, and America. I visited many museums in a short period of time, looking particularly at portrait paintings. Because of the changing role of the museum in Western societies, and because of the strong disturbance of one's identity through the ubiquitous media, I started to wonder what people could still read in any given piece of art, if they could read anything at all.

I began to photograph people in museum galleries who were looking at paintings that also depicted people. I wanted to recall what art initially meant by creating a kind of time-tunnel situation, an act of remembrance.

I worked with a large-format camera, which allowed for big prints. And from the beginning I decided to let the series of museum photographs be very small, no more than twenty-five images. I perceived that showing the work in this limited series would be like an event, a sort of performance. I also realized that the visitors must not be posed, because even if I succeeded in arranging a situation with visitors that was fairly natural, you could instantly feel that it was, in fact, artificial.

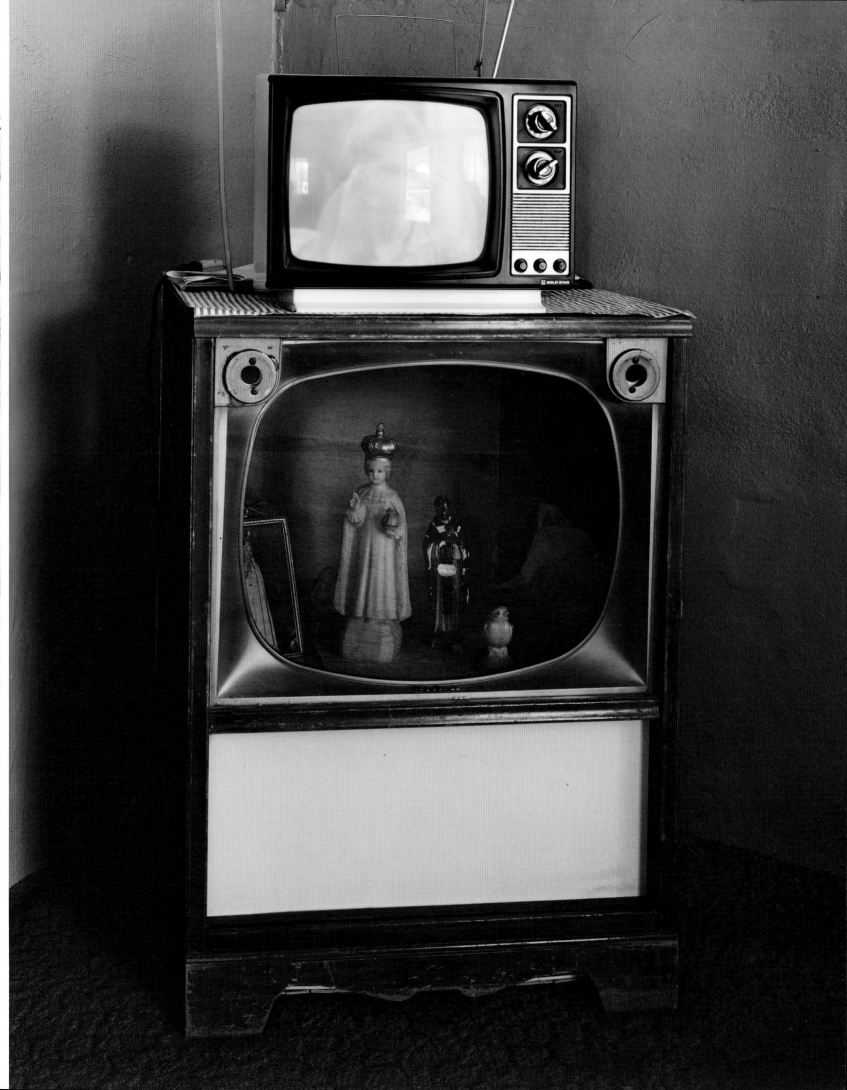

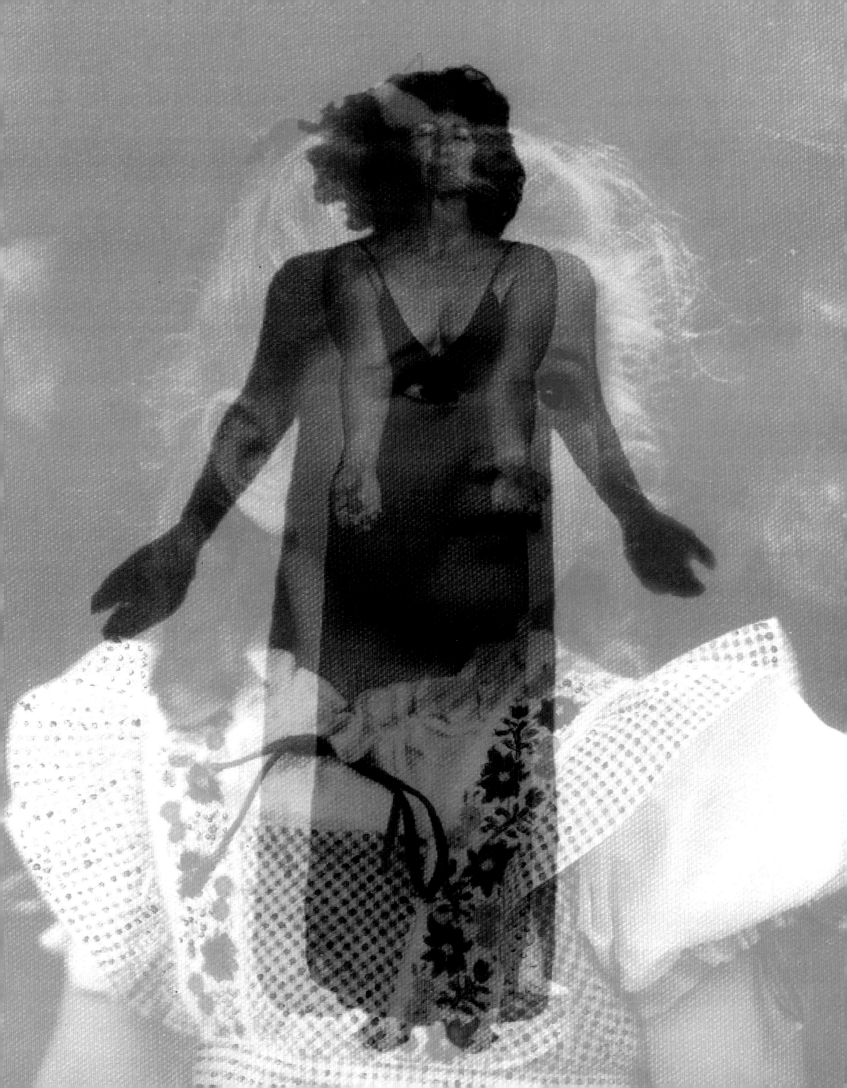

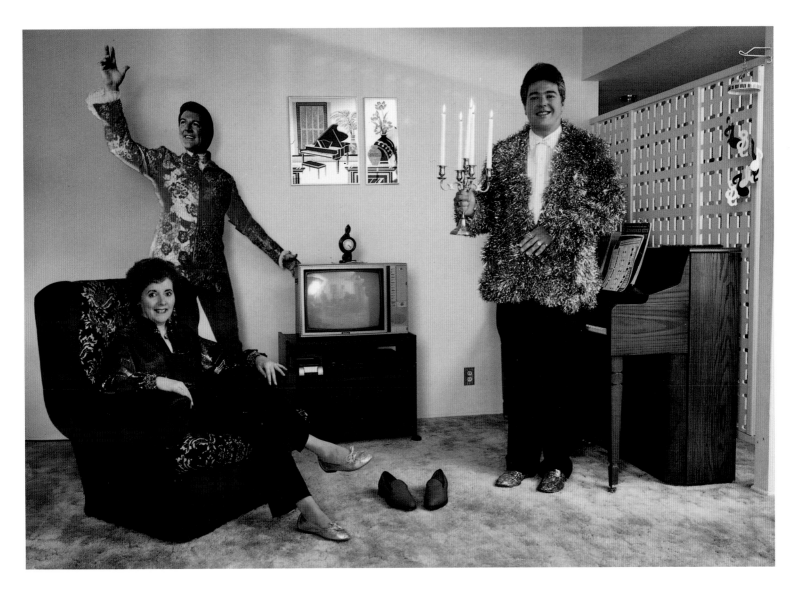

JUDY DATER *Child/Woman*, 1991 *(opposite)*

I like to create fictional narratives that suggest a story or are evocative of an emotional state. My work is based on personal ideas or experiences, or on the experiences of those close to me. My photographs have mainly been of people, myself included, clothed and unclothed. I want to show people as they are, not glorified, no shame—fat, bulges, wrinkles and all. I want the work to be disturbing, unsettling, provocative, challenging, and thought provoking.

I am interested in human nature, theater and role playing, costume and disguise, humor, psychology, sexuality, romance and stories, the dark side of things, the cosmic. I want to explore the subterranean, the hidden side of myself. I am interested in the transformative quality of light. I am also interested in realism, the idea that sometimes truth is stranger than fiction. I want to know the nature of things. I want to know my own true nature.

DAVID GRAHAM *Pauline Lachance and Gregory Mikeska, at a Meeting of the Liberace Fan Club*, Las Vegas, Nevada, 1991

I feel like photography and I are in two separate cars, traveling down the interstate at more or less the same speed, jockeying for position. Perhaps it is this changing perspective that maintains my interest: photography's ability to describe familiar subjects in new ways, its ability to fight against its own inherent realism and to present fresh ideas. These are the things that keep me coming back.

Regardless of the reason, real or perceived, that I love photography, it is still enormously difficult to do. The loading of the film, the arranging of the shapes, these things are not hard to do. It is the determination of *exactly* the right thing to shoot and how to differentiate between truth and surface that is nearly impossible.

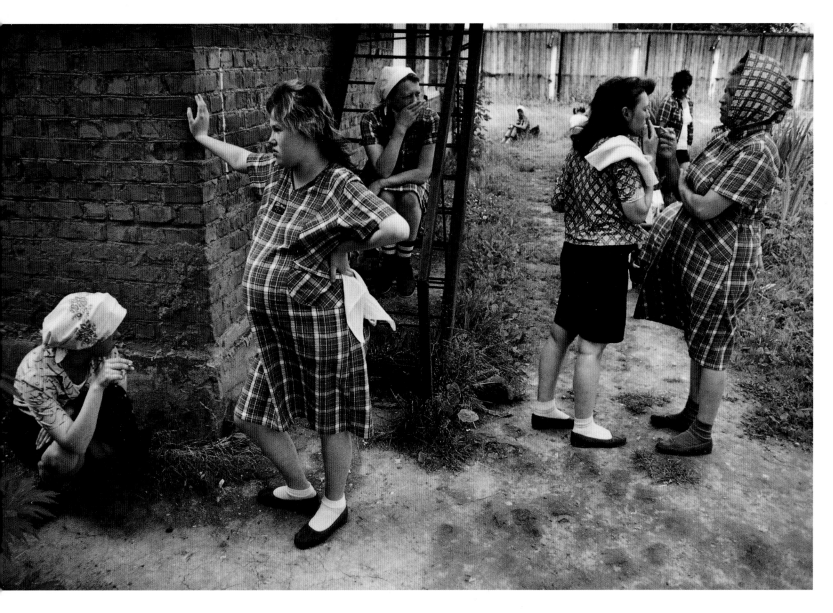

DAVID C. TURNLEY
The Mozhaysk Women's Prison, 1991

A fundamental motivation in my work is a care for the world I live in. I do not see myself as a casual observer. I find myself as compelled by instances of joy—and by wanting to capture moments of joy, and beauty, and jubilation—as I am by more tragic moments. The human experience is one that I look at very seriously, and I find myself driven to document it with genuine integrity.

The question has often been posed: Aren't you scarred or depressed by what you've seen? On some level, certainly I am, but there's the other aspect to my experience, which is that I've had the good fortune to have encountered many people of incredible dignity and integrity: people who believe in something so strongly they are willing to die for it.

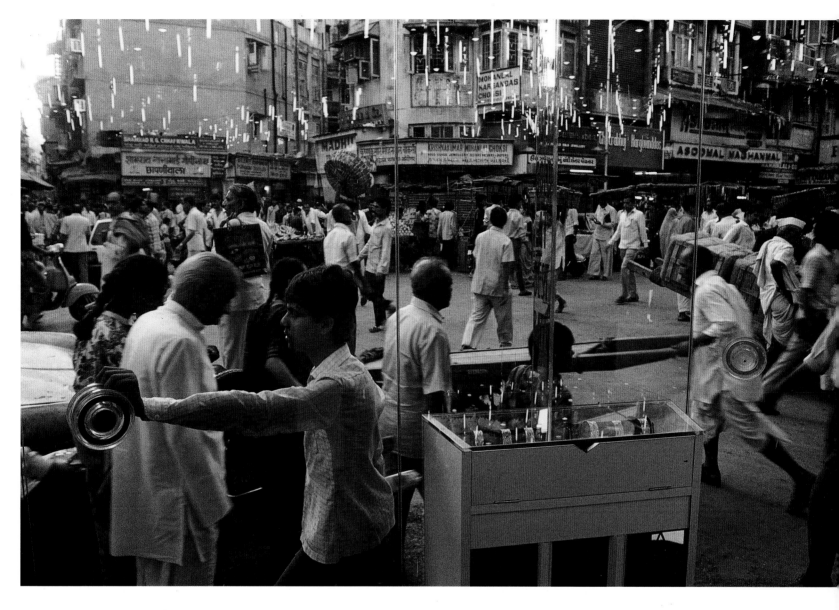

*Photography, to me, is the dewdrop
that reflects my inner and outer worlds
simultaneously. . . . The dewdrop is
the mountain, the river, and
the plain of India.*

RAGHUBIR SINGH
Zhaveri Bazaar, Bombay, India, 1991

Photography, to me, is the dewdrop that reflects my inner and outer worlds simultaneously. I have adapted the idea from Rabindrath Tagore, the Bengali poet who wrote in Satyajit Ray's diary: "I have spent a fortune travelling to distant shores and looked at lofty mountains and boundless oceans, and yet I haven't found time to take a few steps from my home to look at a single dew drop on a single blade of grass."

India is my home. The dewdrop that reflects the substance of India is delicate and fragile and impossible to transport, because the dewdrop is eminently ecological, like all the great art of India. That is, the dewdrop is the mountain, the river, and the plain of India. These are sanctified in Indian life and thought.

Out of this ethos emerges India's artistic sensibility, from the ancient Sanskrit poets to Satyajit Ray. When I have looked at other lands it has always been at the geography and people together. But I have regularly returned to gaze and wonder at that dewdrop at home.

31

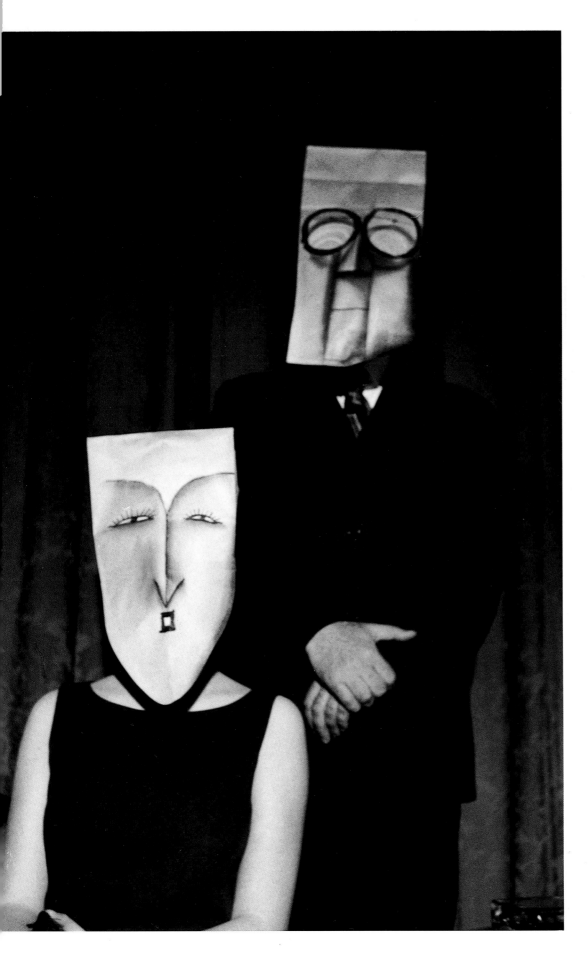

INGE MORATH
Untitled, 1961

Photography is my way of discovering the world and people around me. I am driven by curiosity—my eye and mind excited by the possibility of recognizing a fact in an instant—and, at the same time, by the plastic organization of forms.

Photography is a mixture of concentration, discipline, and patience. I could not work but from my own point of view,

Photography is a mixture of concentration, discipline, and patience.

with respect for my subject. I think one should be thoroughly familiar with one's tools. Outside that, for me, technique lies in deciding from which distance or height to take a picture, a fraction to the left or to the right, which lens to use, which combination of aperture and shutter speed will be best. To be fairly certain of the results of these decisions—made semi-consciously while moving around the subject—is probably in the end what makes you a professional. In my heart I like to remain an amateur, in the sense of being in love with what I am doing, forever astonished again at the endless possibilities of seeing and using the camera as a recording tool.

Pressing the shutter has remained a moment of joyful recognition, comparable to the delight of a child balancing on tiptoe and suddenly, with a small cry of delight, stretching out a hand toward a desired object.

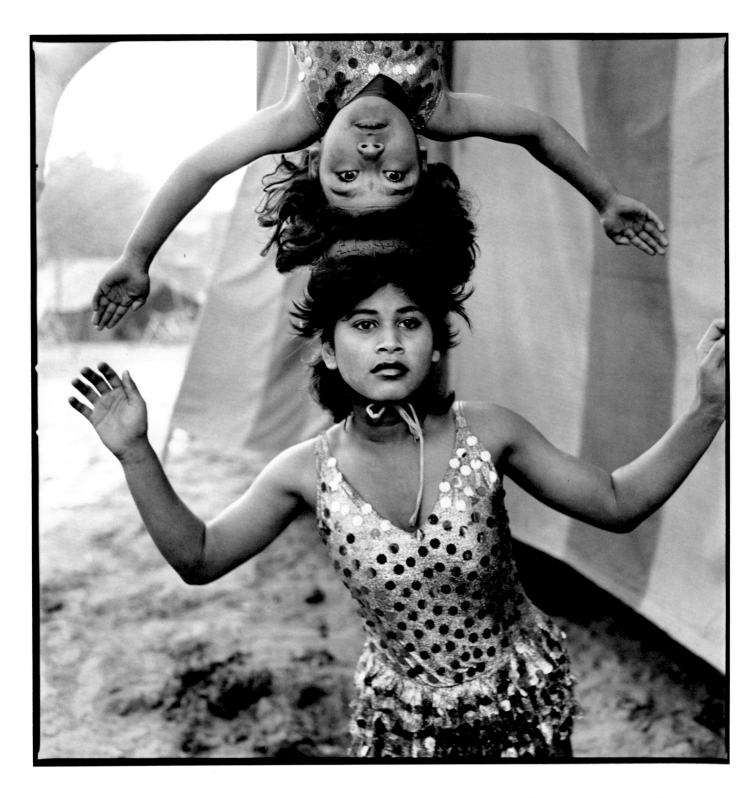

MARY ELLEN MARK *Acrobats Rehearsing, Great Golden Circus*, Ahmadabad, India, 1989

I'm interested in documentary photography that is about universal issues, subjects that have content and depth. The real challenge for me is to go way beyond the initial surface of my subject matter. I am forever hoping that magazines and books will recognize and publish strong work with content. Sometimes this does happen and it's very gratifying.

The circus in India embodies everything that fascinates me. India is the country I love, but it goes beyond that. The Indian circus deals with the universal feelings we all recognize, those feelings that cross cultural boundaries, such as irony, pathos, and humor. It has a great energy, beauty, and a life of its own.

Making these photographs was a wonderful experience. The Indian circus has given me exquisite memories that will remain with me for the rest of my life.

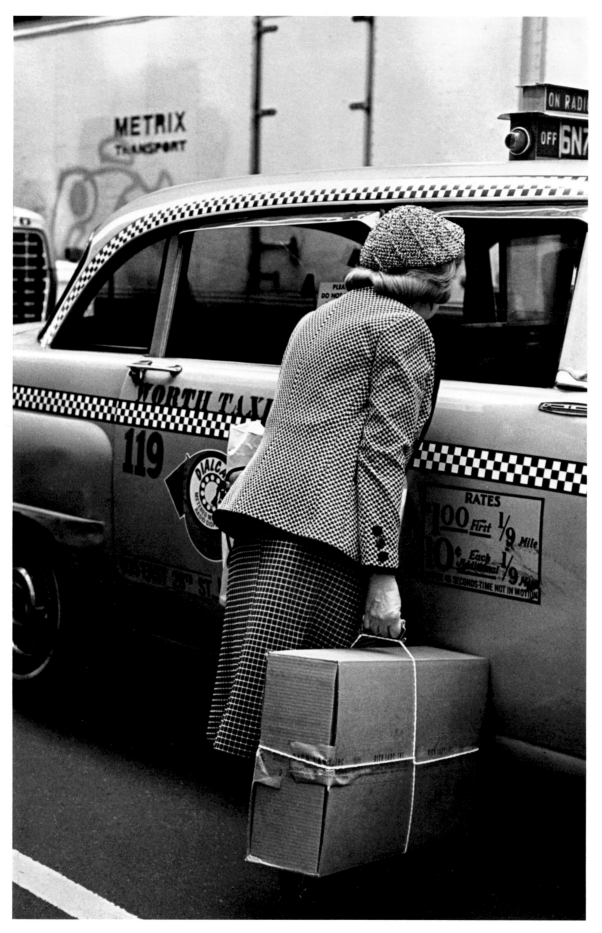

HELEN LEVITT
New York City, 1982

My recent photographs dif-
fer from those I took in the
1940s in that they are more
complex in design.

My content has changed be-
cause the neighborhoods have
changed. People no longer
spend a lot of time sitting
around in the street together.
A lot of my early pictures are,
I think, quite funny. And
these days I tend to look for
comedy more and more.

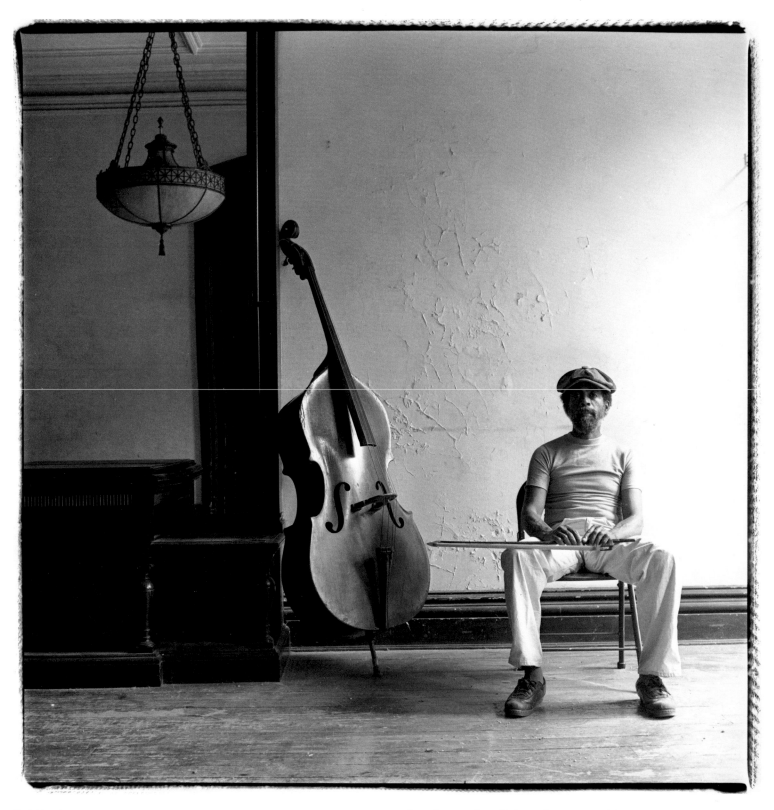

DAVID LEE

My Father: William James Edward Lee III, 1982

I remember when I first looked through my grandfather's Yashicamat. I was probably about fifteen, and it was a couple of years after I'd begun shooting with a 35-millimeter camera. Looking at the ground glass, I became aware of perspectives for the first time—it was like looking at a little movieola. And that's

when I started realizing what composition was.

I am drawn to photography in two directions—the first is portraiture and the other is street photography. Documentation is important to me, too. I identify with the black community, but I've also been drawn to the Latin community. I hope that there is an intimate connection made in my photographs that allows the viewer to go beyond preconceived stereotypes.

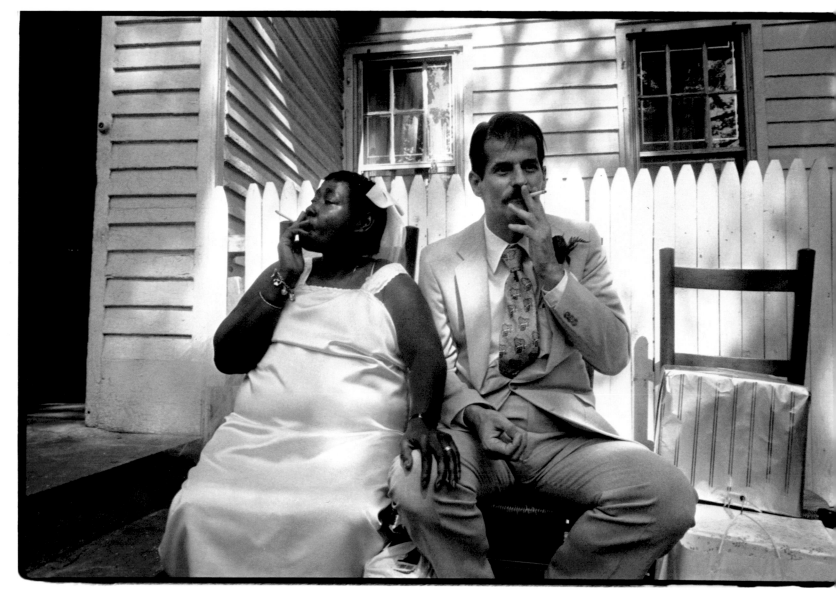

ABIGAIL HEYMAN

From the series "Dreams & Schemes," 1986

 The search for self-awareness, in the guise of a photojournalistic style, motivated me to photograph. In 1968 my small camera and versatile black-and-white film were at the ready all the time. I photographed my family, friends, the first things I saw when I woke up, strangers who invited me into their lives. This was the beginning of the Women's Movement, and my personal pictures about women spoke of national issues. In the following years, photojournalists were increasingly illustrating other people's stories, rather than envisioning their own. Artists were rewarded for communicating style, rather than emotion. Photojournalists and artists sat at separate dining tables. As time went on, each knew fewer participants in the other group. They each knew less of the logistic, aesthetic, and emotional concerns of the other. I have felt like an outsider in both camps. There are losses, and gains, in these changes. Photographs are more complex, and visually more demanding now. Yet, much of the spontaneity—for which the camera shutter is ideally suited—has been lost. For me, a good photograph is one that combines aesthetic power *and* emotional presence.

Photojournalists were increasingly illustrating other people's stories, rather than envisioning their own. Artists were rewarded for communicating style, rather than emotion.

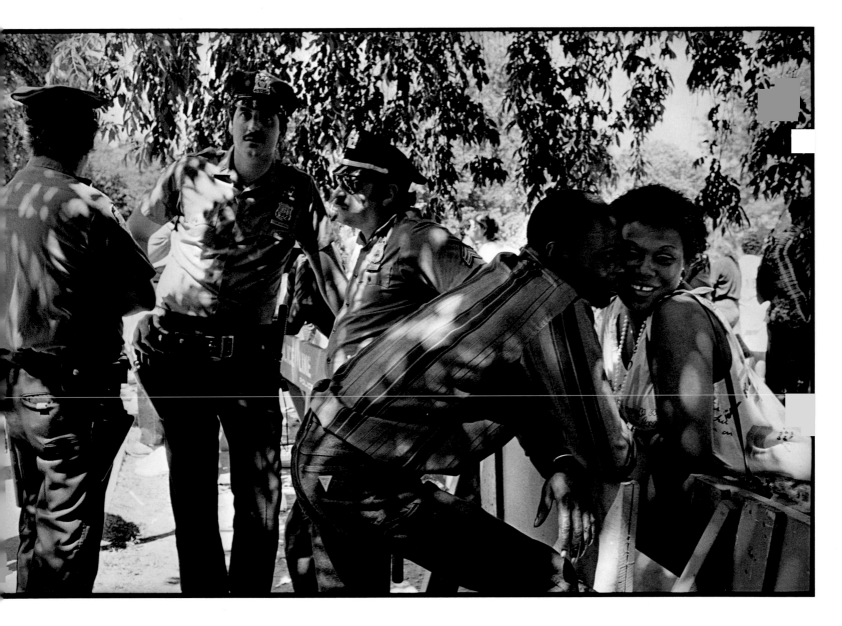

MARILYN NANCE

Couple and Cops, New York City, 1986

Because of the history of African enslavement and the separation of our families in the "New World," I am always mindful when photographing that the people in front of me could in some way be related to me. With a wink from my ancestors and community, I am constructing a giant family album.

I used to work in an advertising agency. I almost got fired when my grandmother passed away and I spent a week away from work. Who cares if your ninety-three-year-old black grandma dies? Get back to work, or else. Another woman's grandmother died and the ad agency planted a tree in Israel. These inequities happen every day, all day—they've been happening all my life. All my mama's life and my grandma's life. And my son is seeing the same thing. I'm fighting the same fight as my mother and my mother's mother, only now in different arenas.

When I was a child, my mother used to tell me that everyone was the same—same stuff: eyes/heart/hands/blood, etc. Equal.

That's what she wanted me to believe. And I do. One evening while reciting my litany of corporate-world struggles to her, she revealed, "I thought things would be different for you." It sounded like she was crying.

Things haven't really changed for black folks, and we know it. The old folks know it. The middle-aged folks know it. Young folks know it—we all know it. We nod to each other when we see ourselves on the street. (That's why white folks think all black folks know each other.) We share a secret . . . that we are human beings, that we love, that we invent, that we brush our teeth, that we vacuum our rugs, that we throw out our junk mail. All of that. We carry in each of us all the stories that are withheld from the history books and kept out of the media, erased from common knowledge. My work deals with the souls of black folks and our quest for social change.

What has changed? Well, now I'm being asked to tell my story of how things haven't really changed.

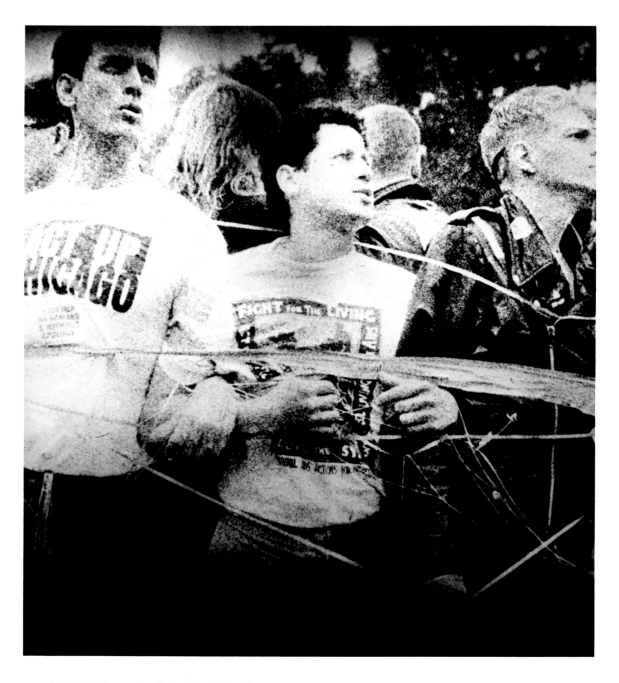

BRIAN WEIL *ACT UP (AIDS Coalition To Unleash Power) demonstration, National Institutes of Health, Bethesda, Maryland,* 1990

Although I'd been a photographer for years, I began all of this without any idea that I would ever photograph. Back in 1984 or '85 I thought the idea of taking pictures of people with AIDS was just horrifying. I felt that I really had not seen any imagery that was anything other than exploitative or terrifying. And knowing this disease so intimately, I did not think photography was the way to explain it, at least not in a functional way.

I spent a year and a half working with the Gay Men's Health Crisis. I wasn't taking any photographs. Since the early eighties I had friends who were sick and some who had died, but I never photographed them. And then I was working with a family in Brooklyn, a mother, father, and two kids who all had AIDS.

When the child was dying, about a year after I had met them, the mother asked me if I would take pictures of her baby, and that's how I got started.

And then I slowly started photographing friends and various situations. In 1987, I left GMHC and I started a pediatric AIDS program at Metropolitan Hospital. We had twenty kids who were HIV-positive. I worked there for a couple of years and took photographs. In 1988 I started traveling and helping to start and train community-based AIDS organizations in third-world countries where I was also taking pictures.

I haven't taken a photograph in two years. And I'm actually relieved not to be photographing. I'm helping to run one of the largest needle-exchange programs in New York City now.

It's become impossible for me to understand the magnitude of this epidemic. We live very unnatural existences.

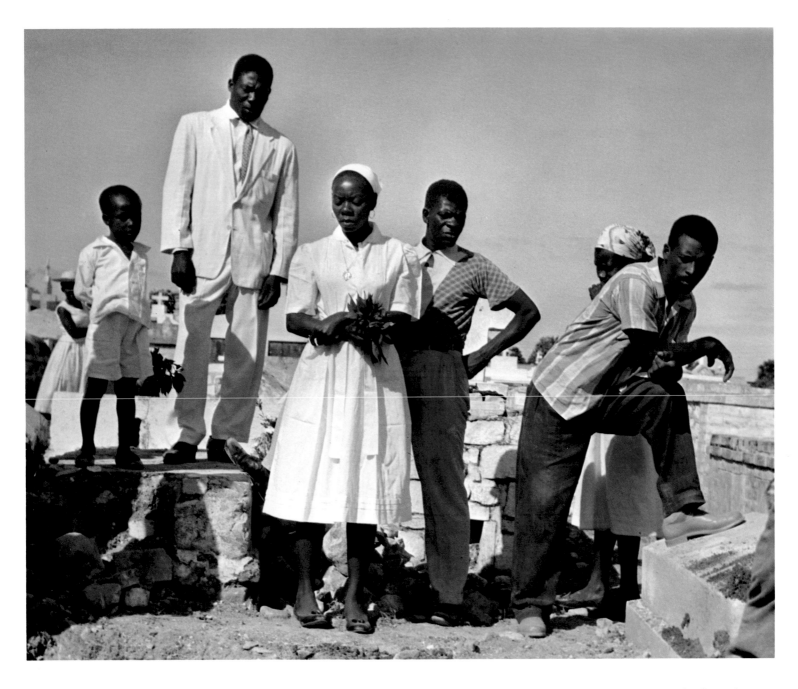

WALTER ROSENBLUM
Funeral Group, Haiti, 1958–59

Lewis Hine came into my life when I was nineteen and, by his friendship and example, showed me the road I might follow. And then there was Paul Strand, who, also by example, made me see how a simple sheet of photographic paper might become alive with the wonders of the world. From him I learned that anything can be photographed if it has meaning for the photographer, that subject matter is inexhaustible if one is willing to explore its richness, that beauty can be found in a cobweb in the rain, in a bit of sand under a stormy sky, or in the face of someone you love. He made me see that photography must always be treated with respect and given one's best effort.

In my philosophy, the meaning of life derives from the people one has known and loved. I have met my share of evil people and know what they are capable of—I was at the liberation of the camp in Dachau—but I have always held that evil is not inherent in men and women. I still believe that within a caring society, only the best in people will flourish. That is the spirit that has moved me to photograph.

Beauty can be found in a cobweb . . . or in the face of someone you love.

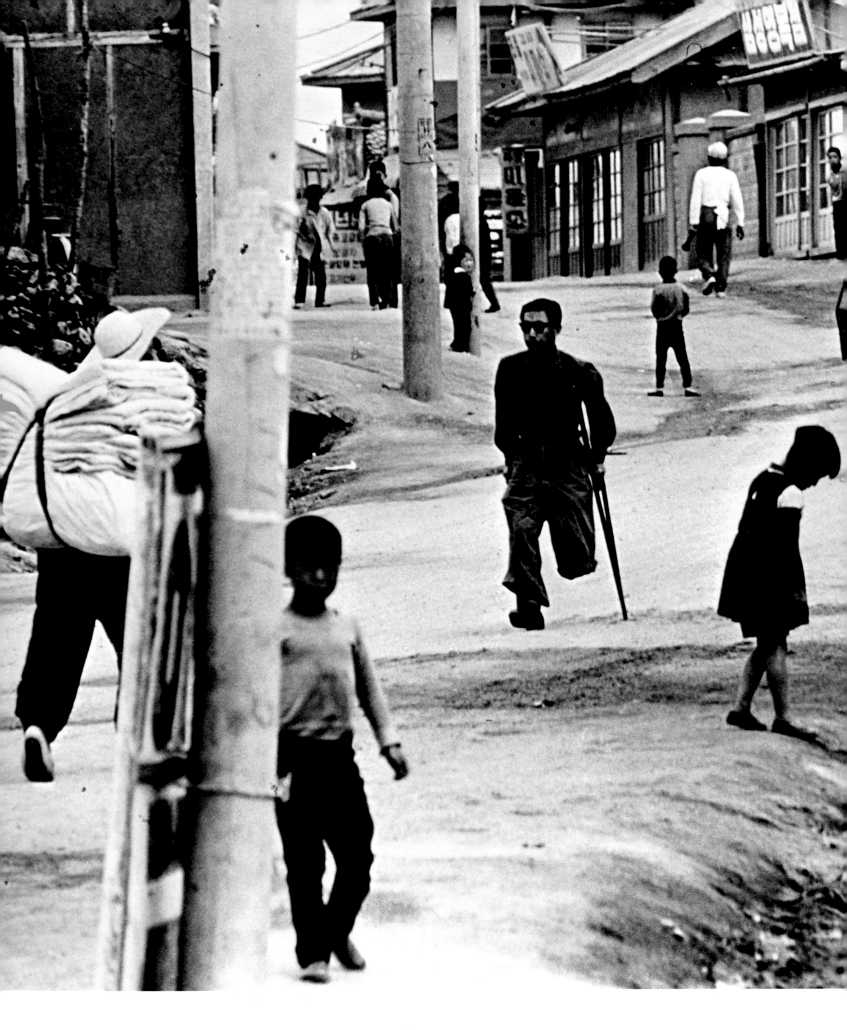

PHILIP JONES GRIFFITHS
South Korea, 1967

In a perfect world the photographer would be handed a ticket and dispatched to some situation with the assurance that his or her interpretation would be eagerly awaited by those anxious for edification.

Alas, the world is far from perfect.

Today the photographer is sent off to illustrate the preconceptions, usually misconceptions, of the desk-bound editor — an editor biased not by any knowledge of the subject but by the pressure to conform to the standard view of the world

And yet, despite all this, one perseveres. The reason has to do with a terrible need to be there, to see for oneself, to vindicate one's skepticism of the spoon-fed nonsense doled out by our media.

ordained by the powers that be. Any deviation from "party line" is forbidden and any fact not corroborated by a journalist renders the photographer "unreliable" or, even worse, "emotional."

Stories are rejected because they have no "American" angle, editors restrict discussion to new ways to skimp on expenses, color is insisted on (to offset the black-and-white ads), the travel department tickets you to Dakar instead of Dacca, and the publisher announces, "Kill the Africa story — too many blacks already this week!"

And yet, despite all this, one perseveres.

The reason has to do with a terrible need to be there, to see for oneself, to vindicate one's skepticism of the spoonfed nonsense doled out by our media. And, to be sure, because there is no more wonderful way to spend one's three-score years and ten on the planet earth.

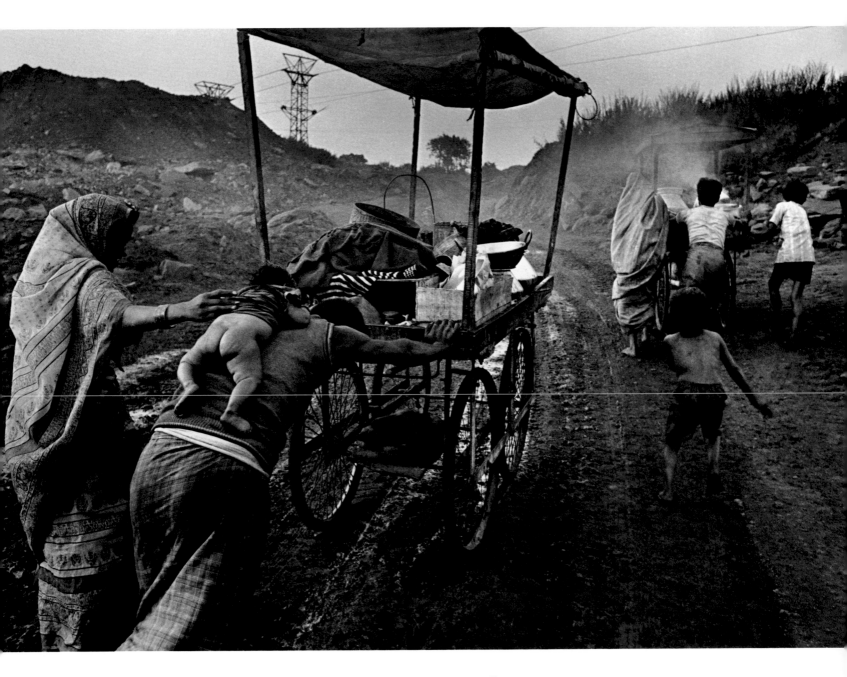

RALPH GIBSON From the series "Karnak," 1992

After thirty years as a photographer I am beginning to understand the creative process as it has revealed itself throughout my career. It occurs to me that at the beginning one works passionately to *learn* photography. This takes some years, and the craft is usually formed during this period. Then as time passes one finds oneself more in the role of *serving* the medium. These middle years move very quickly and offer greater aesthetic satisfaction. Then, as in the example of several masters that I have been privileged to know personally, it appears that by having devoted oneself totally to the medium, one *becomes* photography.

I believe that the medium of photography prevails entirely as an act of faith in the souls of those who love and practice it. And so every photograph becomes another subtle variation on the theme of the medium itself.

SEBASTIÃO SALGADO
Coal Mine, India, 1989 (*above*)

Throughout a million years of human evolution, mankind has been characterized by an ability to do, to make, to build, to grow, to construct. I have been photographing the portrait of an end of an era, as machines and computers replace human workers. What we have in these pictures is archaeology. What we see now are remains, things linked to the past but basically finished. This project pays homage to the worker on the eve of the twenty-first century, as diversified technologies irrevocably alter the human landscape. I am striving to create a visual almanac whose image will be informative and evocative, serving as a reference guide to the past as we reflect upon and build our future.

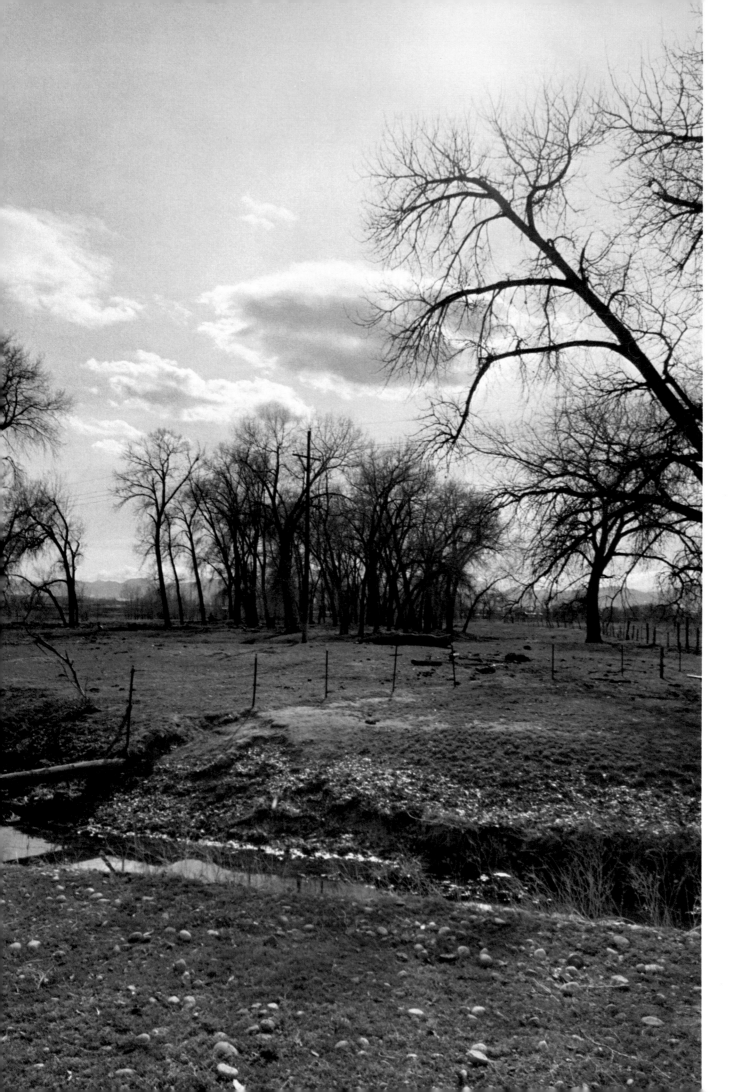

ROBERT ADAMS *St. Vrain
Creek*, Longmont, Colorado, 1987

Urgency is what first distinguishes *Aperture* at its best. Caring, though, doesn't always have to lead immediately to politics. Old copies of *The Flame of Recognition* (*Aperture* 12, an issue on the work of Edward Weston) and *Frederick H. Evans* (*Aperture* 18) are alive with caring—both that of the photographers and of the editors. Nancy Newhall quotes Weston's phrase, "a pepper—and more than a pepper," and we see this is true. Beaumont Newhall emphasizes Evans's title, "In Sure and Certain Hope," and we see its aptness.

What messages could be more urgently given?

HENRI CARTIER-BRESSON
L'Isle sur Sorgue, Provence, France, ca. 1989 (*below*)

For *Aperture*'s fortieth anniversary, you ask me my thoughts on the future of photography. I am no fortune-teller.

In my opinion, it depends on the eye and heart of each photographer—provided he does not allow himself to be misled, either by the conceptual or by the lures and misuses of technology. Only a fraction of the camera's possibilities interest me—the marvelous mixture of emotion and geometry, together in a single instant.

Translated from the French.

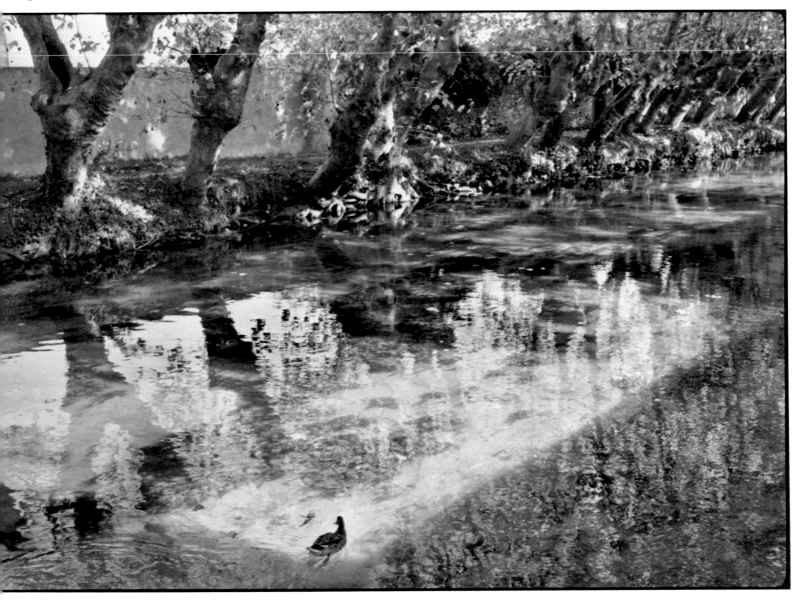

BRETT WESTON

From the "Hawaii" series,
1978–1992 (*opposite*)

I began photographing in Mexico in 1925, under my father's influence. He loaned me his camera and I fell in love with it then and there—and that was almost seventy years ago.

I'm photographing in Hawaii now: leaves, lava . . . various things. Hawaii

The reason that I don't talk about photography is that I'm too busy doing it.

has an immense range of subject matter. It's very tropical and very beautiful.

My work is my language and I don't discuss it very easily. It's difficult for me to verbalize my feelings, or to intellectualize my work. In fact, it used to annoy me when Ansel Adams and Paul Strand yak-yak-yakked about what photography meant, and I told them so. The reason that I don't talk about photography is that I'm too busy doing it.

I've had an incredible photographic life—and I'm not through with it.

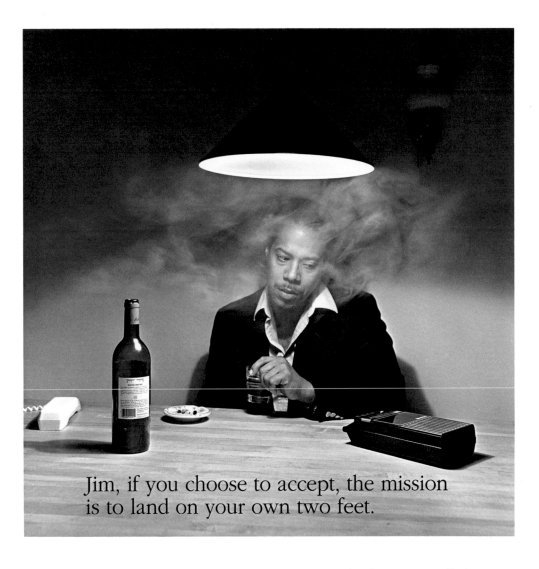

Jim, if you choose to accept, the mission is to land on your own two feet.

CARRIE MAE WEEMS

"Jim, if you choose to accept, the mission is to land on your own two feet," 1987

Photography can still be used to champion activism and change. I believe this, even while standing in the cool winds of postmodernism. In this regard, perhaps what is important to consider is that our age necessarily demands, as Allan Sekula eloquently put it, "a new documentary," one that develops new forms, new visual possibilities. And one that still embraces a photography that is essentially humanist; a photography that encompasses the complexity of our diverse experiences and all the rest of it.

Postmodernism looked radical, but it wasn't. As a movement it was profoundly liberal and became a victim of itself. Precisely at this historical moment, when multicultural democracy is the order of the day, photography can be used as a powerful weapon toward instituting political and cultural change. I for one will continue to work toward this end.

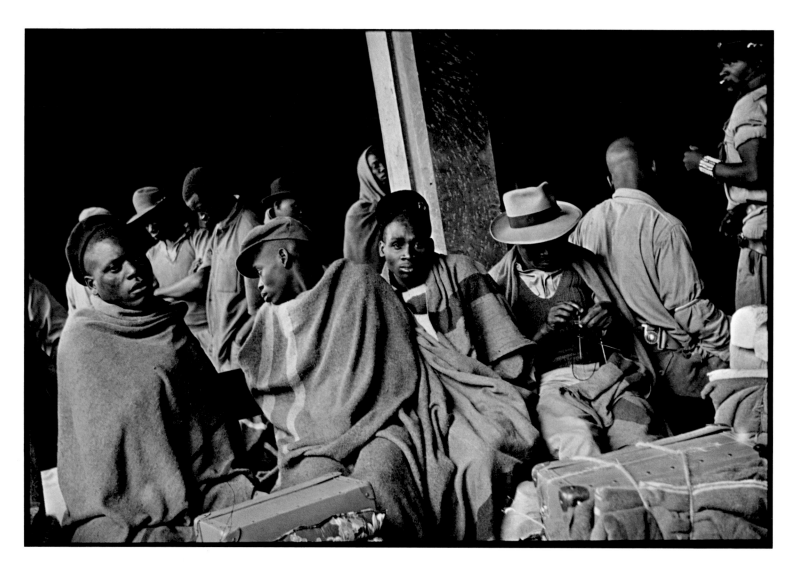

DAVID GOLDBLATT

Nyassa Miners Going Home, 1952

Arriving at a suburban railway station in Johannesburg one wet morning in December 1952, I saw a large group of African men on the platform. They were clustered tightly together among suitcases, boxes, sewing machines, windup gramophones, and bundles of bedding. I took them to be migrant workers, miners who had completed their year's contract in a gold mine and who now, laden with gifts for their families, were waiting for a train to take them home: a way of life here for millions of black men since the 1880s.

Approaching the men on the platform I learned that they had been working at the Crown Mines and were returning to Nyassaland (now Malawi). It would take some of them two weeks by train, bus, and foot to reach their homes; yesterday they had walked across the city to this station, their luggage on their heads. They had been on the platform for twenty-one

hours and no, they would not mind if I photographed them.

They had a quiet and gentle containment. Some slept, some chatted, others knitted. One man played a concertina while those around did a shuffling dance; another cranked a gramophone. One wrote a letter, another took out a comb and mirror every now and then and carefully renewed his parting. Their train pulled in at midday, twenty-four hours after their arrival at the station. If they were impatient at the delay or angry over their treatment, none of them showed it.

In 1965, when I went underground in a mine for the first time, I found almost inconceivable the immense bridges those men must have had to build between their life in the bush of Nyassaland and that in the compounds and tunnels of the mine.

The photographs were a great disappointment to me and I put them away in disgust. In 1982, thirty years after their taking, I looked at them again and printed this one. I have come to like it.

*How can you make art
when the world is in
such a state?*

ALFREDO JAAR
(Un)framed, 1987–91

Reality cannot be photographed or represented. We can only create a new reality. And my dilemma is how to make art out of a reality that most of us would rather ignore. How do you make art when the world is in such a state?

My answer has been to make mistakes, but when I can, to *choose* them.

We are all guilty victims choosing mistakes, and as Godard said, the very definition of the human condition is in the mise-en-scène itself.

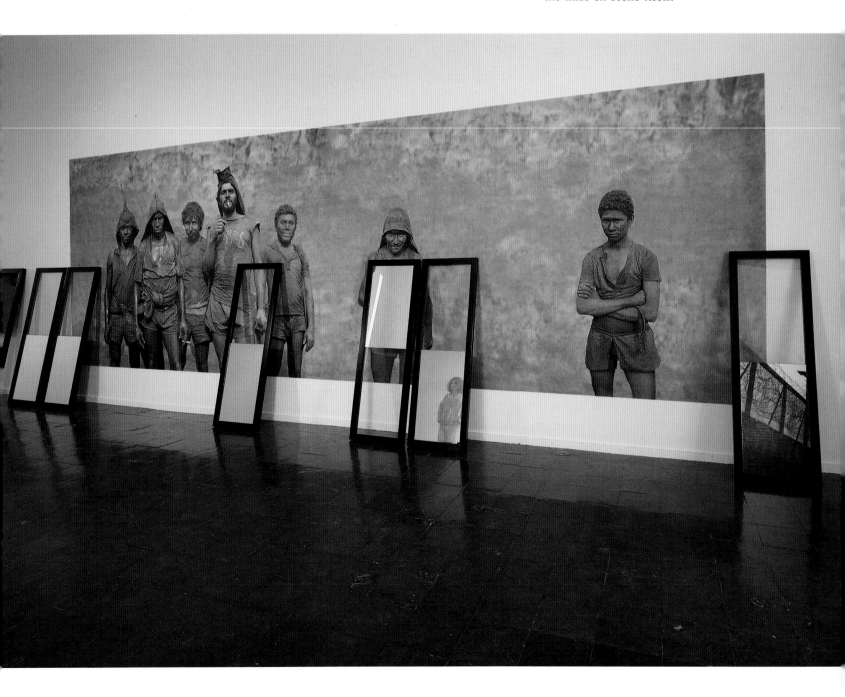

RICHARD MISRACH *White Man Contemplating Pyramids*, 1989, from "Desert Cantos" Prologue

The white tourist, the white photographer, the white archaeologist, the white historian, the white entrepreneur, the white educator, the white architect, the white physician, the white painter, the white filmmaker, the white physicist, the white mathematician, the white politician, the white Supreme Court Justice, the white psychologist, the white philosopher, the white cultural theorist, the white surgeon general, the white academic, the white activist, the white choreographer, the white cinematographer, the white fashion designer, the white C.E.O., the white priest, the white scholar, the white rabbi, the white advertising executive, the white author, the white poet, the white screenwriter, the white toy maker, the white critic, the white journalist, the white astronomer, the white police chief, the white teacher, the white general, the white playwright, the white emperor, the white engineer, the white chemist, the white prime minister, the white president, the white collector, the white gallery director, the white sculptor, the white composer, the white baseball commissioner, the white newspaper owner, the white publisher, the White House, the white economist, the white jury, the white sociologist, the white audience.

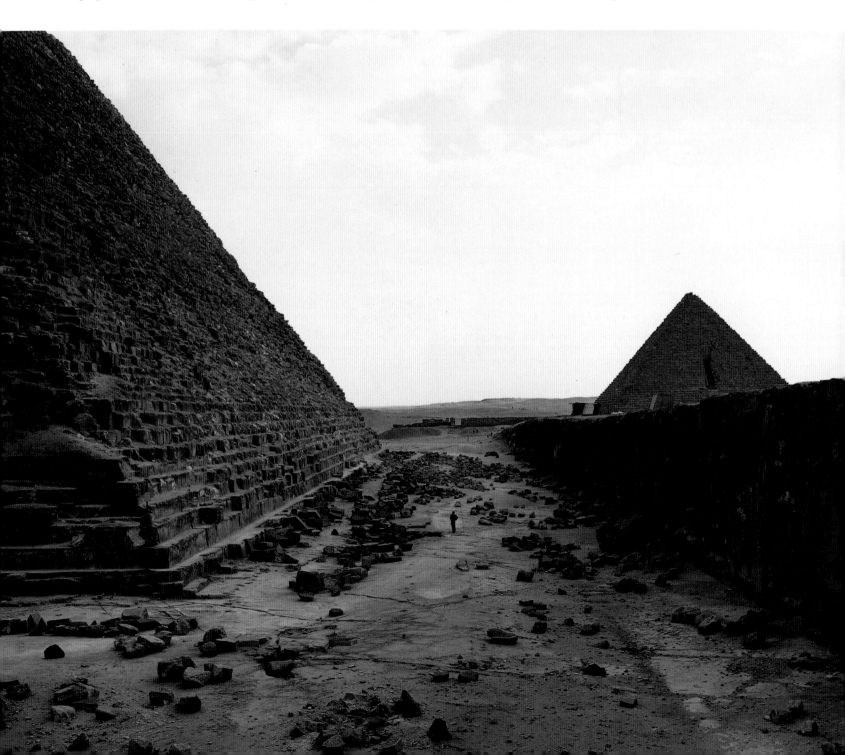

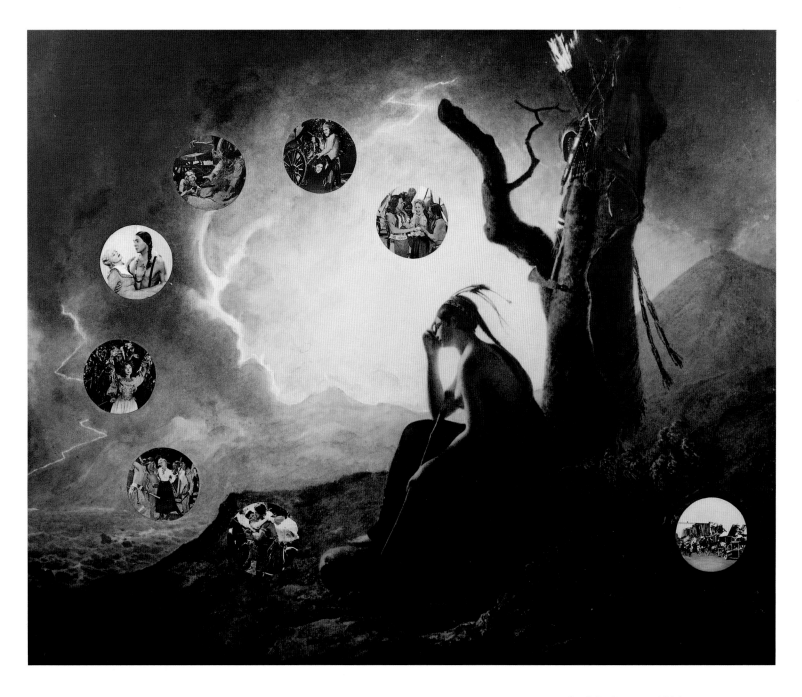

I try to reveal that structure of thought: an iceberg with the photograph tiny at its tip. I want to be the woman who put the kink in the straightness of photography.

ELAINE REICHEK *Red Delicious*, 1991

The trouble with photography is that it gives you the illusion that it's possible to see purely. In a limited way, the camera catches so accurately what's in front of it that you think that's all there is to say. In fact, of course, the very idea that that's all there is to say is part of an attitude, a cultural stance, a politics, an ideology, a whole mental structure of which the camera is only a small part. In the work I do with photographs—choosing them, coloring them (or not), copying them in other media—I try to reveal that structure of thought: an iceberg with the photograph tiny at its tip. I want to be the woman who put the kink in the straightness of photography.

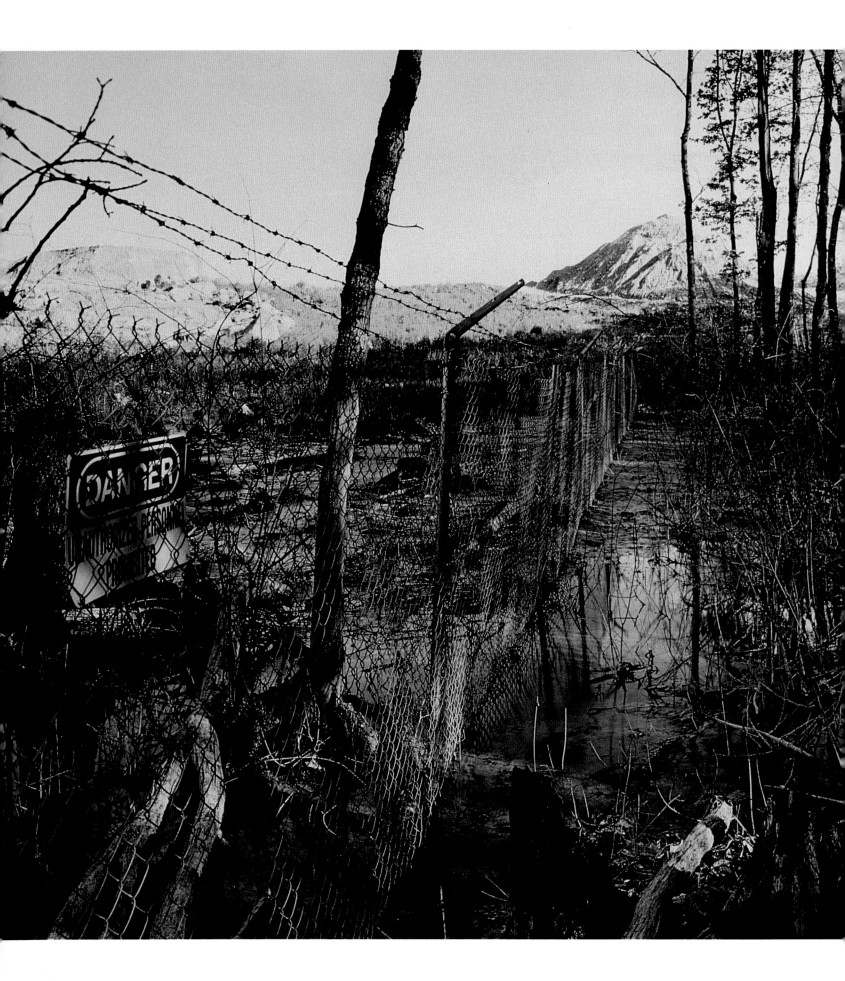

WILLIAM CHRISTENBERRY
Landscape, near Tuscaloosa, Alabama, 1990 (*above*)

When I first began making photographs in the late 1950s, I used a Brownie camera. In 1977 I started using an eight-by-ten Deardorff and since that time have concentrated my efforts on it. In 1989, after a ten-year hiatus, I took up the Brownie again. It was interesting to discover that this small and unsophisticated camera could be used with reasonable ease and confidence along with the demanding large-format camera.

Photography has always been a part of my artistic activity, which also involves painting and sculpture. I use these media to express the many concerns and feelings in my life and about my background. It is the relationship of all of these means of expression and their totality that best exemplify my work.

FRANK GOHLKE *Nyanza Superfund Site—Near Sudbury River*, Ashland, Massachusetts, 1990

My first teachers, my mentors, were Walker Evans and Paul Caponigro. That wasn't a conscious choice. Fate placed both of them in my way. On the other hand, those people define the two poles of the way I approach the world. I found myself taking from both of them what I needed to create a version of the world that seemed complete and satisfying to me.

The documentary style is an incredibly flexible and useful one. It's a wonderful tool for establishing the credibility of the version of things that's in the photograph—a kind of rhetorical device or rhetorical strategy. It's always felt very natural to me, because I want a person to end up thinking about the world, and to think about it in a way that is transformed by the experience of art.

It's important to me that the pictures lead you back to your primary experience of walking around in the world. I think the look of fact is what enables one to do that. I see the experience of pictures as a kind of cycle, a kind of circular motion in which you're in the world, then you enter the picture and you're in a different world (it's not the same as the one you live in, but recognizable as one you might live in). And then you're returned to your world with an enlarged sense of its possibilities. That seems to me the moral basis of what I do and, I guess, of a certain kind of art.

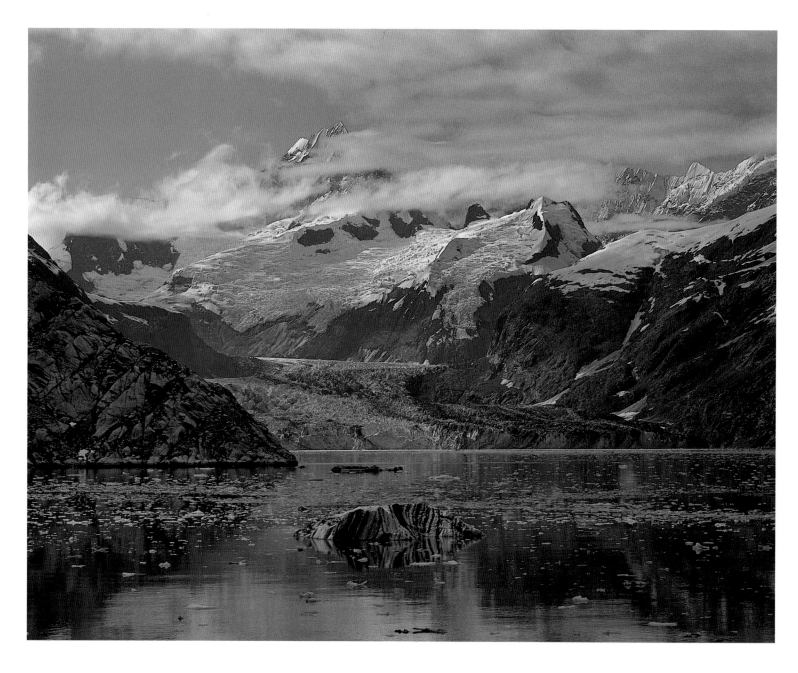

ROBERT GLENN KETCHUM

John Hopkins Inlet, Glacier Bay, Alaska, 1987

I am troubled by the media's presentation of the world environmental issues, especially the ozone layer. Now that we know there's an ozone hole and that ultraviolet is one of the most destructive ray lengths known, we're waiting to find out what the biggest immediate repercussion is going to be. My contention all along has been that it's going to be on the food supply. The first impact was significantly measured in the last two years; the American Antarctic Station reported last summer that the phytoplankton bloom had decreased 30 percent, that the level of ultraviolet penetration into ocean water is much deeper than they ever suspected, and that they're beginning to find abnormalities in the fish populations. That affects the whole Southern

Hemisphere. So, if you begin collapsing this phytoplankton food chain—and it is a tier, a structure—you see that you don't have small fish if they don't feed on phytoplankton, and you don't have medium-sized fish if they don't feed on smaller fish, and so on down the chain.

In my exhibits, I clearly set people up for a euphoric experience with these beautiful pictures and then strategically threaten them with troubling ones. In the end I've downloaded very distressing information to them without disturbing their viewing experience in the gallery. They still have a good time. But I hope they come away with a completely different sense of the environment. And that is the guile of working with photography as I choose to.

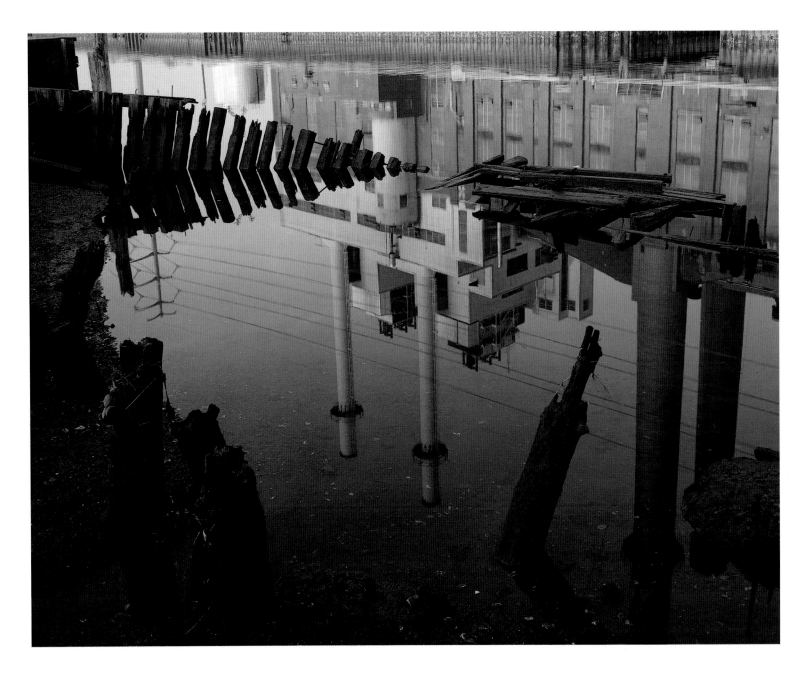

RICHARD BENSON *New Haven Power Plant*, 1990

I am now making pictures in color, using an eight-by-ten view camera and Ektachrome film. I put this color positive on a drum scanner, and make a set of color separations from it; not just the conventional group, which records the primaries of cyan, magenta, and yellow, but also separations for reds, greens, and blues, as well as for black and white. The transparency ends up being separated into ten or twelve different colors, each recorded on a different piece of film.

Using these separations, I then make the finished picture with acrylic paints, using pigments for the colors instead of the normal dyes. These pigments are not spectrally pure; the colors don't add up to make the proper secondaries, so if I put cyan over yellow, I don't get the clear green of normal color photogra-phy. However, because I have a separation for green alone, I can apply this with its own color, containing opacity, and thus can build up any structure of tone and palette that I wish in the picture. This solves the biggest problem for me in color photography, and that is that the poor photographer, who wants a color such as a specific red, must make this color indirectly, by using magenta and yellow, instead of handling the color directly.

None of my current work would be possible without the computer. The scanner I use for these acrylics can only slice the colors apart because of its digital system of recording, and the control it permits would have been unthinkable without the electronic revolution. The present infatuation with the computer as manipulation device, altering pictures or creating imaginary worlds, is of no interest to me.

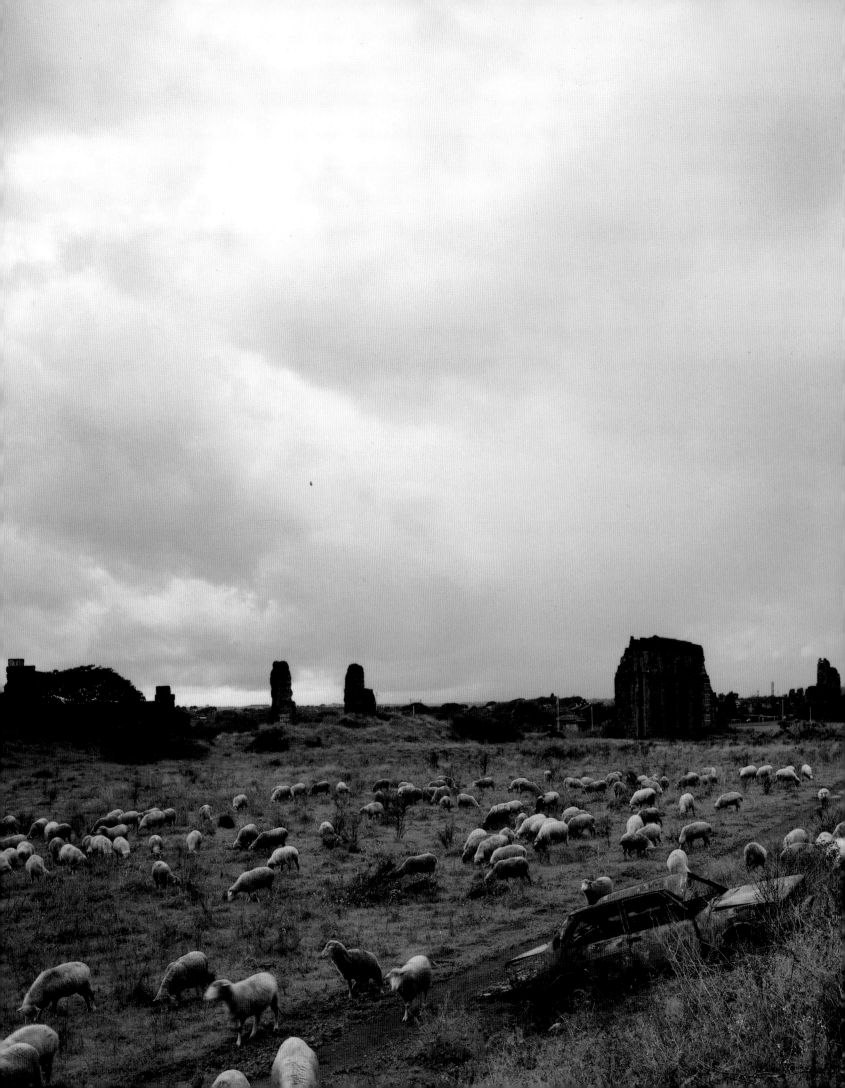

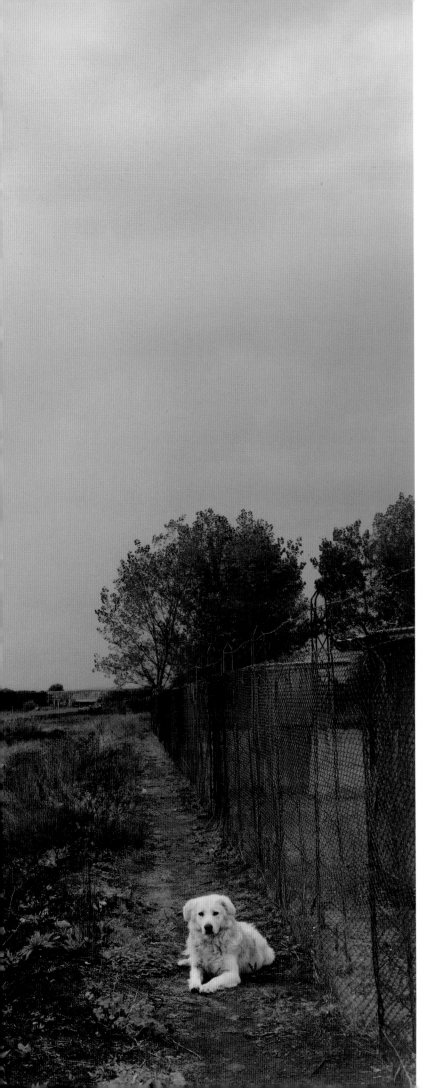

JOEL STERNFELD *Sheep Grazing in the Vicinity of the Claudian Aqueduct*, Cinecittà, Rome, 1990

In March 1989, when I first began to photograph in the countryside near Rome, I met a shepherd.

"How many days old are these lambs?" I asked.

"Days?" he responded with a Roman shrug. "One hour!"

Over the two years I spent in Rome, I encountered him from time to time. On the day I made this photograph, he came up and asked, "Always with a camera?"

I resisted the urge to reply, "Always with sheep?" and simply nodded yes.

MASAHISA FUKASE *Untitled*, 1992

What I am interested in is always myself, and how my own senses have reacted to social phenomena I have witnessed. For the past three years or so, I have included myself in all of the photographs I have taken. I did not intend these as self-portraits, but my interest was in the relationship, or the sense of distance, between me and the phenomena I was photographing. I used an auto-focus instamatic camera that I held myself.

I got tired of this series, so at present I'm photographing crows. I am shooting the crows with a 1000-millimeter tele-photo lens every day between 4:30 and 5:30 P.M., when they return to their nest here on the veranda of my office. At the same time, I am doing line drawings, and I am thinking of compositions of the crows and the line drawings. I'll probably make black-and-white composite photographs first and add color drawing afterward.

I think good photographs are produced when you have fun working on them. These days I believe that if the artist is enjoying the work, the people looking at it will probably enjoy it too. *Translated from the Japanese.*

Good photographs are produced when you have fun working on them.

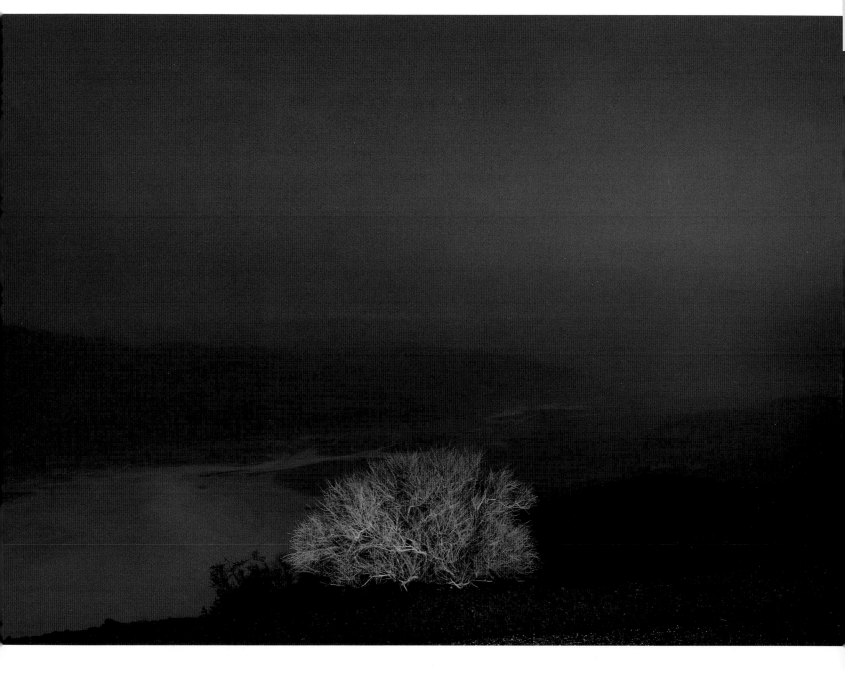

LEN JENSHEL *Dante's Point, Death Valley National Monument, California*, 1990

Edward Abbey observed in his book *Desert Solitaire* that the three questions most asked by tourists of park rangers in the National Parks are: Where is the bathroom? Where is the Coke machine? How long does it take to drive through this park?

When we arrive at a new place and find it formidable, foreign, or frightening, we reach for the mundane, the familiar, the comfortable. We rely on personification and metaphor to get a handle on what is most eccentric and unfathomable. And the machine—whether train, plane, automobile, or camera—happens to be one way in which we enter into this landscape. Perhaps even more important, it is our ticket out.

The photograph reproduced here was made at dawn at a sce-

nic overlook in Death Valley National Monument in California. When I first pulled up to the precipice and saw how the car's headlights were casting a surreal and religious glow on the golden bush, I leaped out of the car in order to set up my camera and tripod quickly, in an attempt to render this magical sliver of atmosphere and time.

While setting up, another person with a camera and tripod approached me as moth to flame, and upon seeing the illuminated bush began to beg, stutter, and plead with me to give him permission to photograph "my" bush. Although I laughed at the absurdity of the assumption of my owning a piece of the landscape, I have often wondered if he got a better picture than I did.

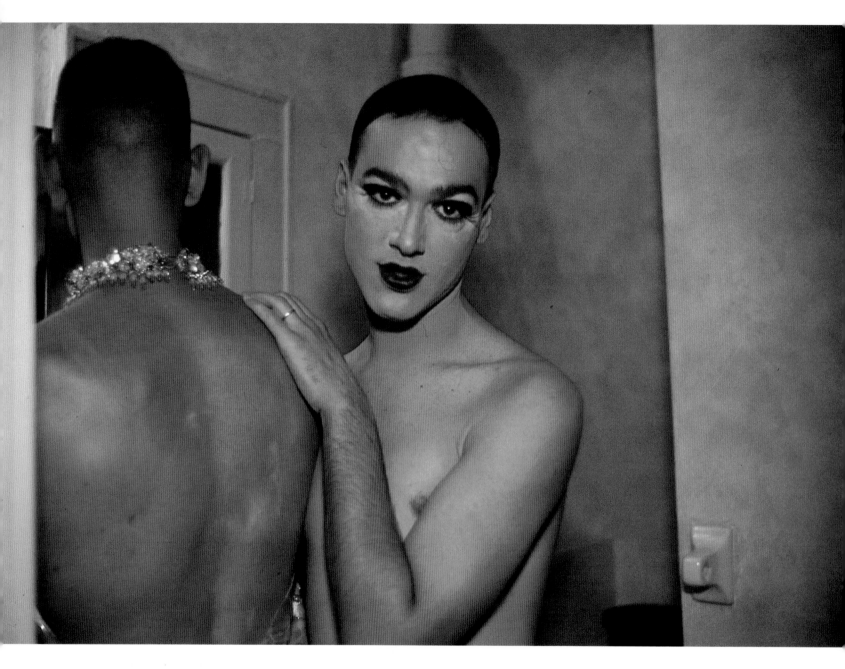

NAN GOLDIN
*Jimmy Paulette and Tabboo in
Bathroom, New York City*, 1991

My photography has always been
about trying to stave off loss: of people,
places, experience, memory. Nowadays
it's also my form of safe sex. It's a way
for me to show people the admiration
and love I feel for them.

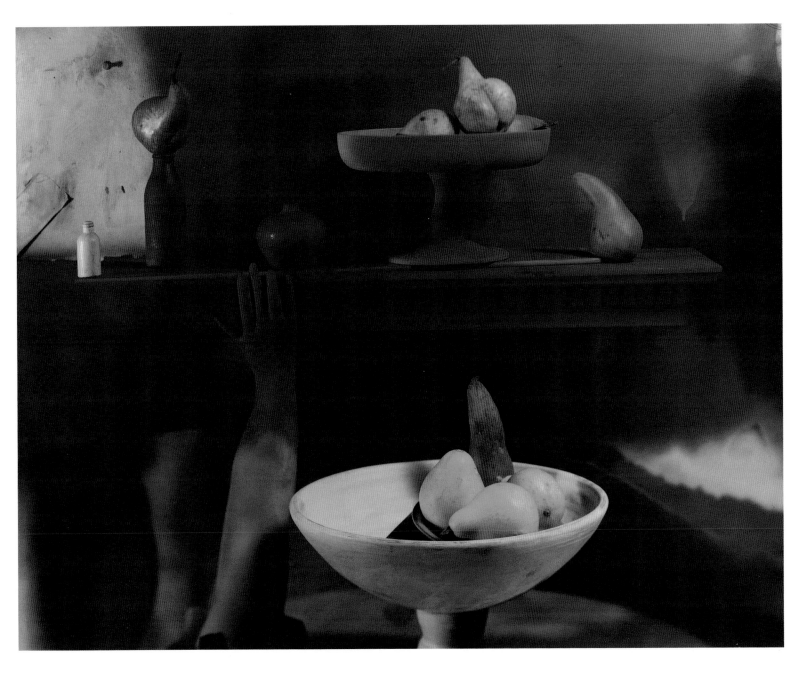

JAN GROOVER *Untitled,* 1989

Although I'm in the south of France, I live north of New York State. The light here reflects that. Long days in summer and short days in winter with a quick and low sun. I am reluctant to say this, embarrassed in fact, but when I got here and saw the light, I realized I didn't know anything about natural light. Before, if I didn't like a dark shape a light was making, I just moved the light and changed the shape. But here, especially in winter, if it's sunny, I've got thirty seconds to make up my mind before the shadow moves and changes everything. That's an en-

tirely different and interesting experience for me. I'm relearning everything.

Things just seem to want to grow here and I'm helping them, even though I know nothing about that either. But it has been on my mind for about twenty-five years (that's how long it's been since I've lived any place but a city) to make a landscape I can photograph, so I've planted twenty-five bushes and thirty-one trees. Two of the trees remain sticks, so I guess they're lost, but I may sometime need a stick to photograph.

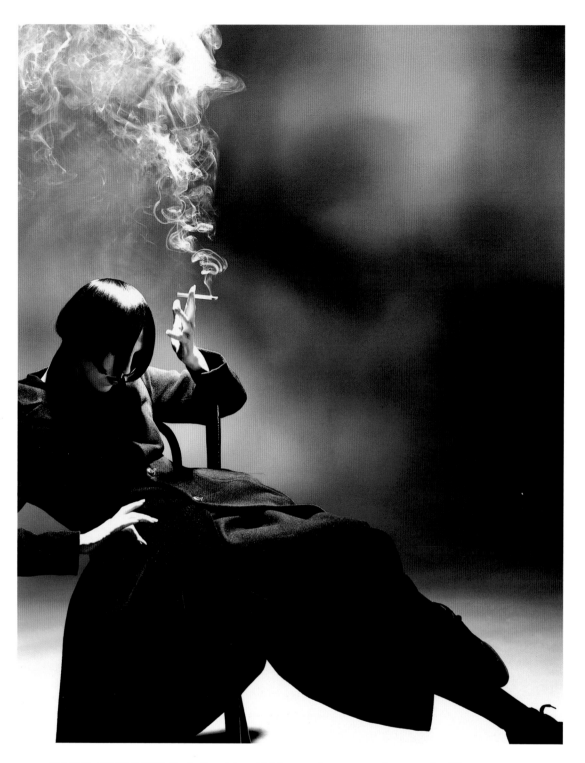

JAVIER VALLHONRAT
Autograms, 1991 (*opposite*)

It is not the relation of the images with the "that was" that interests me. Nor the "this is."

To perceive the photographic medium in relation with the photographic object as the "this is being" allows me to endow the result with a before and an after, a result not so much of a process but as a process itself.

This deals more with the transformation of a process into an image, and again an image that is part of a process.

What interests me is the definition that this process will make of the photographic medium itself.

NICK KNIGHT *Susie Smoking*, 1988

When trying to understand photographers, I feel little is gained with labels like "fashion," "commercial," "landscape," "still life," etc. I believe photography is merely communication, and as a photographer I have opinions on many different subjects. If I were in the position of employing a photographer, I would look for motivation—talent is largely circumstantial.

I treat my photography like a sport: there is no reward unless new times are achieved or new records broken. I get the most satisfaction when I produce images I could never have imagined before I started shooting. This is coupled with a pendulumlike approach to my work. If I tackle a project one way, the next time I shoot I approach it from the opposite direction. This comes from a belief that there are two sides to every decision.

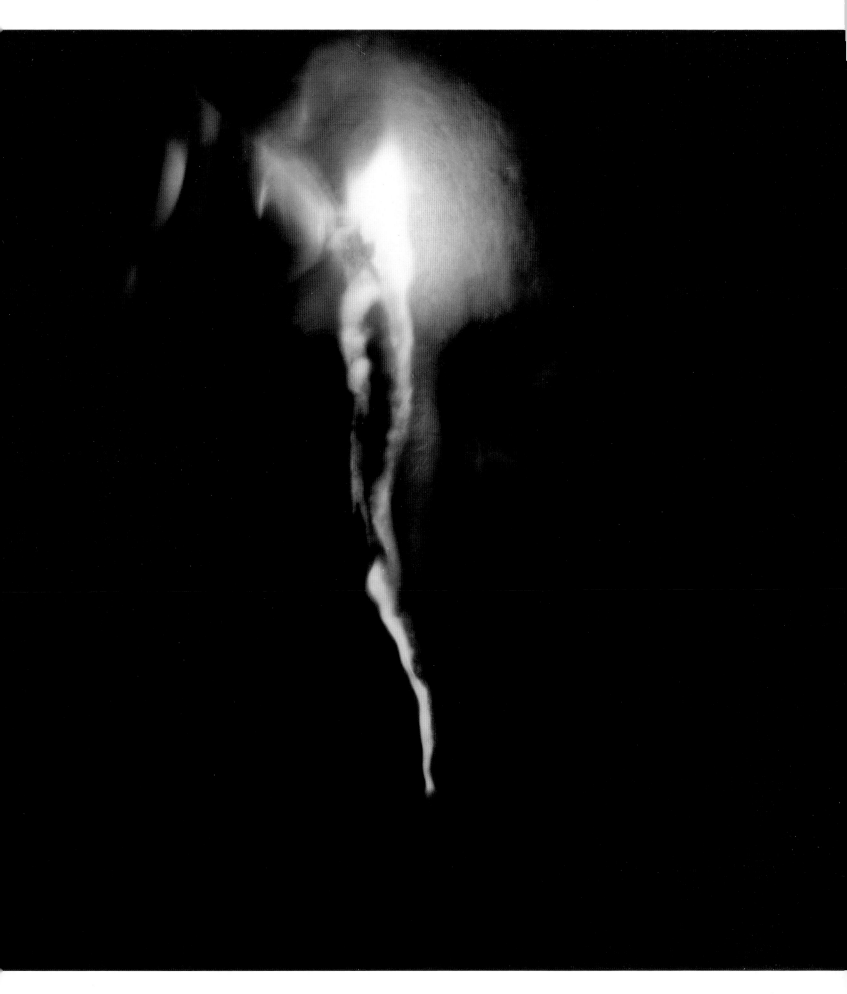

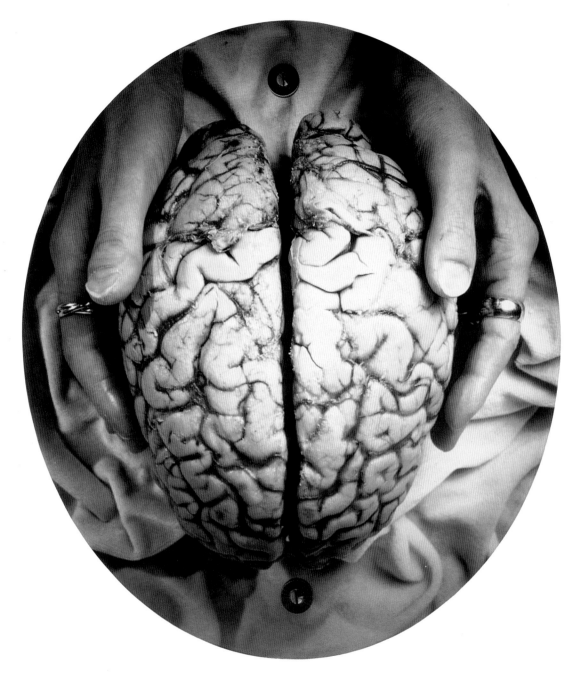

Photography has saturated us as spectators from its inception amidst a mingling of laboratorial pursuits and magic acts to its current status as propagator of convention, cultural commodity, and global hobby. Images are made palpable, ironed flat by technology, and, in

Images are made palpable, ironed flat by technology, and, in turn, dictate the seemingly real through the representative.

turn, dictate the seemingly real through the representative. Pictures and the words that mark or surround them seem to construct and contain us. From photos to movies, to TV, to home videos and computers, these pictures and words have the power to tell us who we are and who we aren't, to dictate what we can and cannot be. But they also suggest that seeing is no longer believing and that what you see is not what you get.

HELEN CHADWICK *Self-Portrait*, 1991 *(above)*

According to Cartesian dualistic philosophy, woman equals body and man equals mind, intellect. By moving away from depicting the body as specifically female, and by focusing on my own body, I wondered if I could explore a form of self-portraiture that would bear evidence or testimony to a common body, a universal body in which you couldn't read gender.

By working with tissues, with meat and organs and other organic material, I have hoped to create encounters with bodies in such a way that it is actually problematic to determine the sex of the figure before you. The images are a kind of mirror to our condition, but they resist being categorized as either male or female. And for me, that is quite a liberating (if disturbing) possibility. I feel increasingly that one's experience with sexuality, even the root of sexual difference, is highly ambiguous. It becomes difficult to make distinctions. And I look for ways of blurring the conventional differences, to move toward a universal, erotic "indifference" to gender.

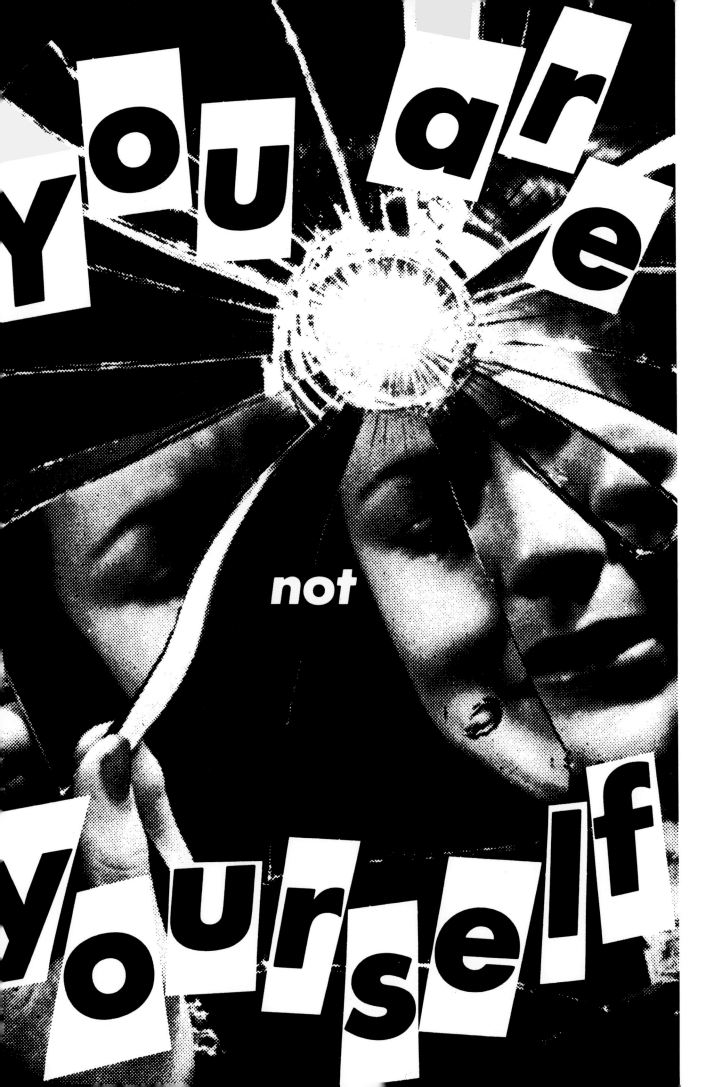

DEBBIE FLEMING CAFFERY
May Van's Camp, 1987 *(opposite)*

My search in photography has been a process of refining my response to what is, for me, mysterious. A lot of my images are of fog, smoke, and steam, often in long exposures, with blurred or out-of-focus elements that help explain the unexplainable. My preference for black

I wish the steam could float out of the prints and touch the viewer on the cheek. . . .

and white allows me to work with darkness, light, and shadow to impart a mood in the work that reflects my sense of mystery in what I see. Certain conditions of weather, appearances of light and shadow, and expressions or gestures of my subjects arrest me, and the resonance begins. I try to distill into the photographs a visual sense of what is beautiful and sometimes confusing to me. An emotional organization of feelings, textures, and light. I wish the steam could float out of the prints and touch the viewer on the cheek, as I felt it while photographing it.

JOCK STURGES
Marine, Maia, Elodie et Gäelle, Montalivet, France, 1991

I am finally and essentially utterly dependent on the tolerance, kindness, and beauty of my subjects. And they in turn will respond only to *who I am*. I cannot alter that equation—nor would I ever. But such relationships are like ever-shifting sand beneath my feet. Children are avatars of the self; they can be generous, mercurial, or capricious. And they grow and change like lightning. These are not their weaknesses; these are their great strengths. As the years go by and the work reflects an accumulation of mutual respect, relationships evolve and the photographs become increasingly a collaboration. They do become easier, but never certain.

Which leaves, of course, Serendipity—ever my sweet ally, my quiet nemesis. All the patience, discipline, and application in the world can come to nothing or mean everything according to her imponderable whim. The inverted image on my ground glass lets me see the basic structure and balance of my compositions, but the vast majority of minute physical detail that rests in any given picture is finally impossible to attend to. When I have the good fortune to make an image with fine transcendent harmonies, some of the credit is mine, still more my subject's, but the crucial final fraction always arrives from points unknown. When, suddenly, it is there, I am always grateful and amazed. And then fearful and abashed. Will it come again? Will it come again?

MARK KLETT *Cul de Sac: Failed Development West of Phoenix, "Estrella,"* July 17, 1991

What keeps me interested in making landscape photographs is the feeling that I still have a connection there to explore. One challenge for me has been to convey the act of perceiving and experiencing the land, as well as what is there to be seen.

So much of what we know, and what we think we know, about the land has first passed through someone's lens. The interesting thing is to make use of this history, not merely to be absorbed into it. For me, landscape photographs begin as the artifacts of personal moments. They get interesting when they become cultural commentary.

What I wish my pictures could do is lessen the distance one

For me, landscape photographs begin as the artifacts of personal moments. They get interesting when they become cultural comments.

often feels when looking at landscapes. I want to overcome the alienation between self and place, the feeling of being dislocated in time, of seeing only scenery, or monuments framed like photographic trophies. I want to show the land as our home, not as a paradise lost. The longer I work with a camera, the more important it is to me to make photographs that tell my story as a participant, and not just as an observer of the land.

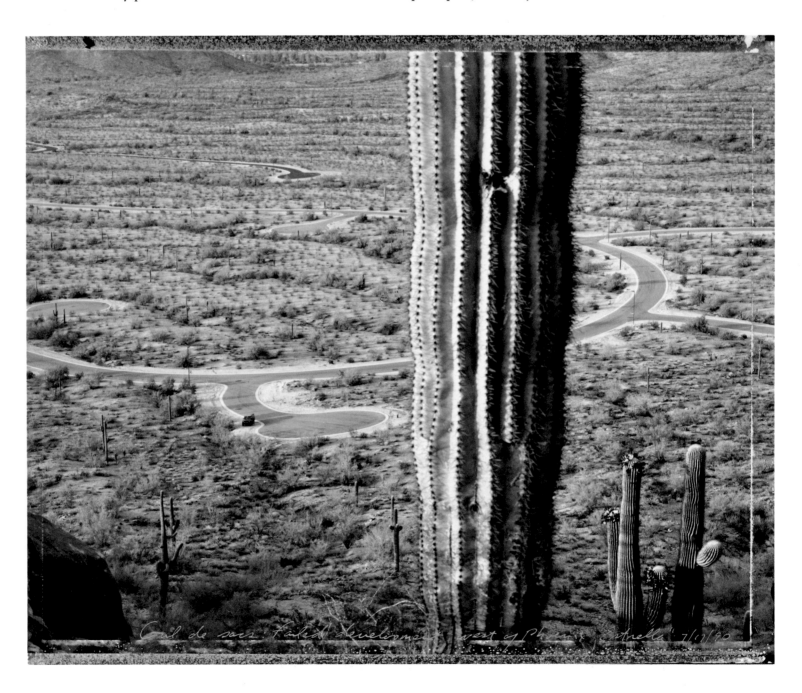

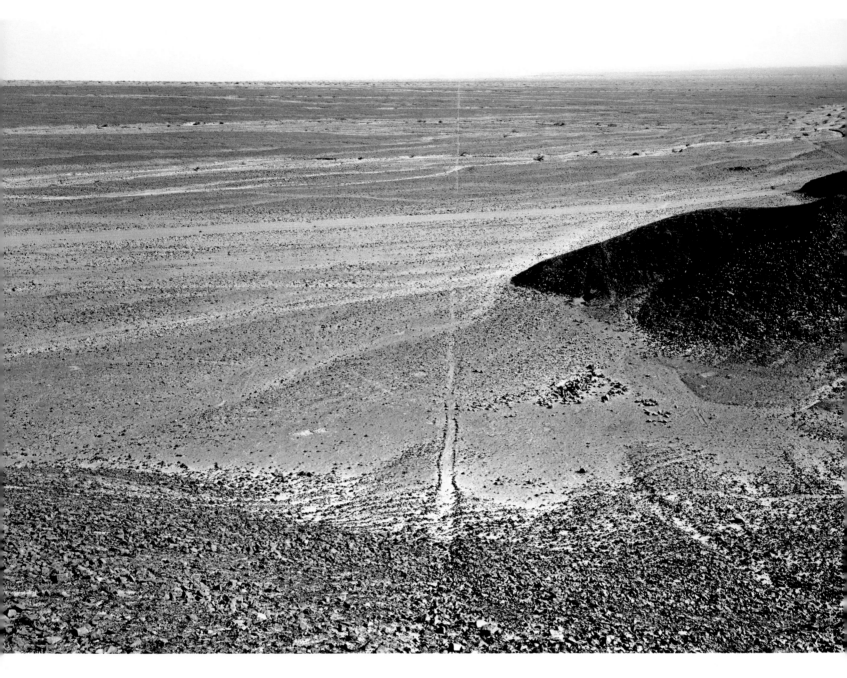

EDWARD RANNEY *Nazca, Peru,* 1985

The sculptor Robert Morris wrote in 1975 after a visit to the Nazca plain that the Nazca culture, in defining its relationship to the "palpable emptiness" of the plain, created lines that he felt effectively mediated between the "flat and the spatial." He observed that, although the lines can be seen more clearly from an aerial perspective, it is only when viewed from the ground that they most effectively transform, and define in human terms, this irrational, overwhelming space that seems to rise vertically before one. Morris's assessment provides a striking understanding of the complexity of seemingly simple space, and the fascination vastness holds for the human eye. At the same time it implicitly reminds me how the legacy of nineteenth-century expeditionary

photography continues to be such an important reference for some contemporary photographers.

The question of how scale affects form remains central to landscape work, whether we are considering the shape of space that nineteenth-century photographers of the American West have left us, or are examining our own redefinition of the contemporary landscape. Robert Adams suggests that landscape pictures can give us three areas of insight: geography, autobiography, and metaphor. How we address each of them depends, of course, upon what attention we pay the content of our pictures as well as their form. Neither is necessarily easily defined. But we neglect one at the risk of the other.

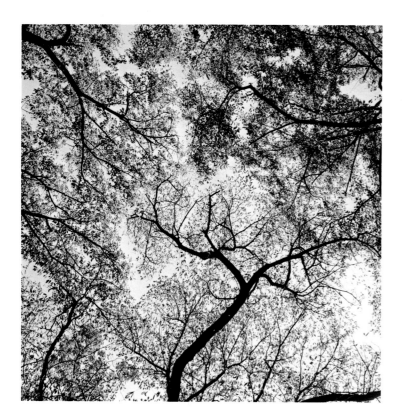

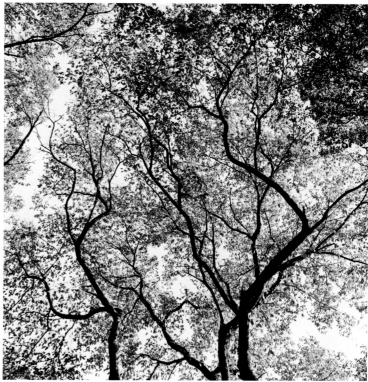

HARRY CALLAHAN
Ansley Park, Atlanta, 1991 (*above*)

I have always lived in simple places. There is nothing extraordinary about these places, but somehow I find them beautiful. In Michigan, for instance, the highest hill is about 150 feet. It isn't spectacular like the western United States and, even though I have been out there, I find beauty in the landscape in Michigan. I feel that, instead of photographing a sand dune, I can photograph a footprint in the sand; instead of a mountain, a dense group of trees.

As a child, my mother taught me religion in the moral sense, and early on I was motivated unconsciously by it. Later, I felt that I wanted to do something that would benefit humanity. I wanted something important, something spiritual in my life. And as these feelings developed, I found that my spiritual enrichment came through art. It was then that I realized I wanted to be an artist. That's it. You see, I learn slowly, but every day I seem to learn more.

JERRY UELSMANN
Untitled (Sandcastle in the Parlour), 1990

In the 1950s, when I was studying photography, the hierarchy was such that the ultimate in so-called fine photography was the work of Edward Weston, Ansel Adams, and Wynn Bullock. There were a few other people, but it was still pretty much a purist approach.

I remember years ago the *New York Times* had a camera page. They didn't really deal with photography on the art page. The first photographers they included on the art page were nonthreatening to the art world, which was basically the world of painting. And among the painters, at that time, Abstract Expressionism was king.

Now the interesting thing for me is that when I first got my big break at the Museum of Modern Art, while my work was controversial on a surface level, I was still emulating Ansel Adams's technical richness. I wanted that sharpness, that tonal range. But I began to explore other possibilities for the photographic image.

I rely very heavily on intuition once I get into the darkroom. I don't want my methods to sound too casual, because I do spend a lot of time examining my contact sheets, trying to find points of departure before I go into the darkroom. But I still keep it an open-ended kind of experience.

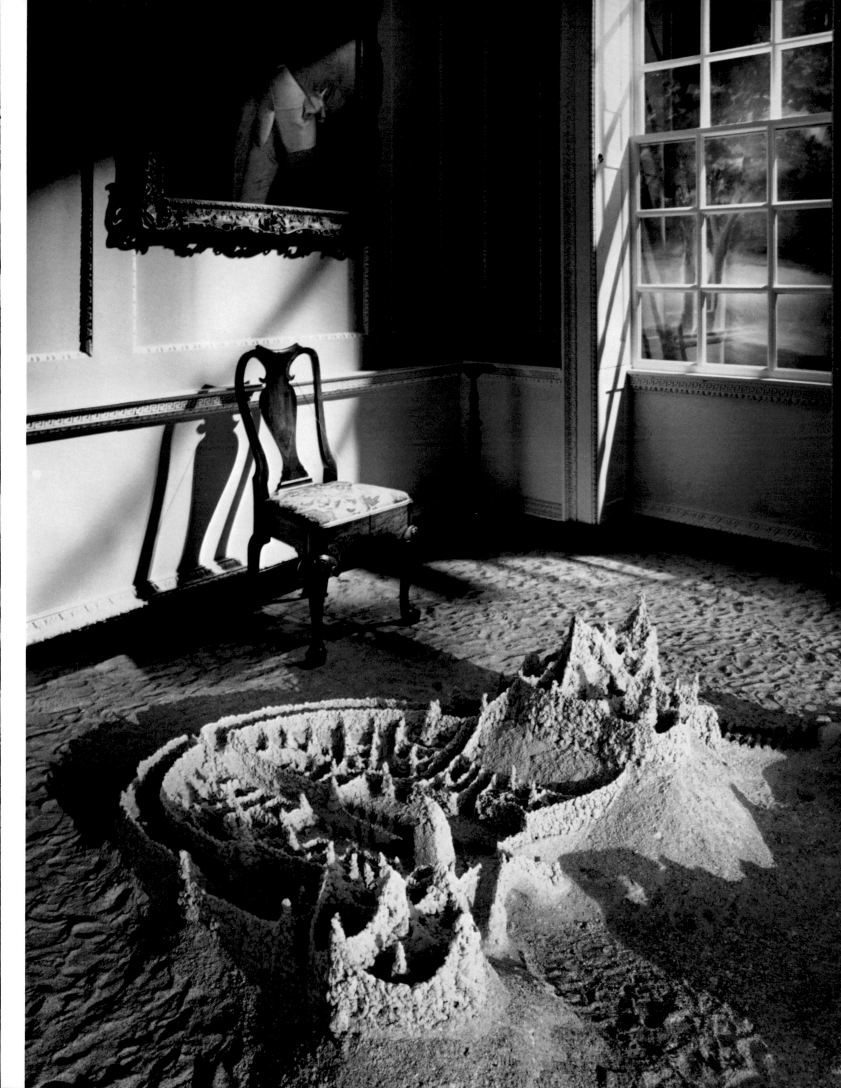

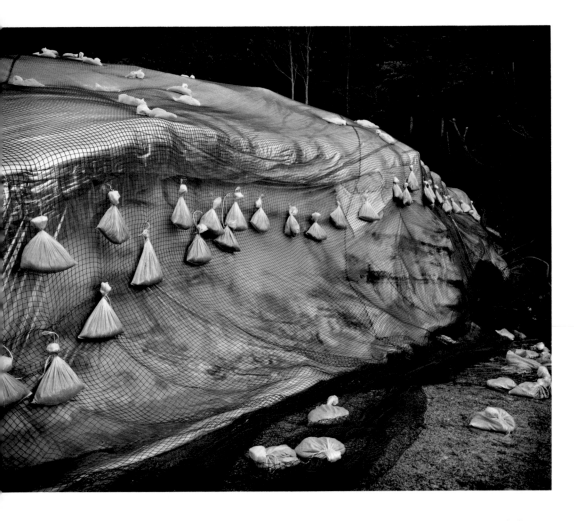

MARILYN BRIDGES
Arrows Over Rise, Nazca, Peru, 1979

I have been making aerial photographs of the landscape for the past decade. We are earthbound creatures: our thought and vision are quite understandably linked to the physical plane, and we ignore or at least minimize transcendental experience. Pilots, astronauts, undersea explorers, even mountain climbers, are fortunate. They must learn to function in alien environments and to experience unique perspectives. Seeing from above is not consistent with seeing from the ground. It is not just a matter of "up here" and "down there."

When one films and photographs, as I do, at low altitudes, shadows lift objects from the ground, and, instead of cold

Seeing from above is not consistent with seeing from the ground. It is not just a matter of "up here" and "down there."

geometric patterns on the earth's surface, an intimacy is apparent, or regained. There is the unmistakable awareness of warmth of contact and a vivid awareness of interrelationships.

I admit to having a strong affinity for the past. Not that I regard the past as perfect and the present as diabolical. But I do believe that in the past man was more in touch with the natural order of the planet; that indigenous people regarded their land as a living part of the universe; and that man's tenure on the planet was one that balanced the forces of nature with man's needs. From the air, man's past and his present can be seen in isolation and in conjunction. The former seems coeval with its environment, the latter seems dislocated. Part of my purpose for shooting at ancient sites, in Peru, Britain, and Egypt, is to use imagery to reflect upon the sacred knowledge of the past—truths that remain locked in stone and earth.

TOSHIO SHIBATA
Yunotani Village, Niigata Prefecture, 1989

In the late 1970s I received a fellowship from the Belgian Ministry of Education and went to live in the old Belgian capital of Ghent. While I was experimenting there with a wide variety of artistic techniques and media, I found a copy of the Aperture monograph, *Edward Weston: The Flame of Recognition*. The direct expressive power that Weston's photographs possess and the special appeal of photographic prints was clearly communicated to me through that publication. Those photographs also had the power to overwhelm all of the different means of expression I had learned to that point. After reading *The Daybooks of Edward Weston*, my vague interest in photography became a decisive one.

Translated from the Japanese.

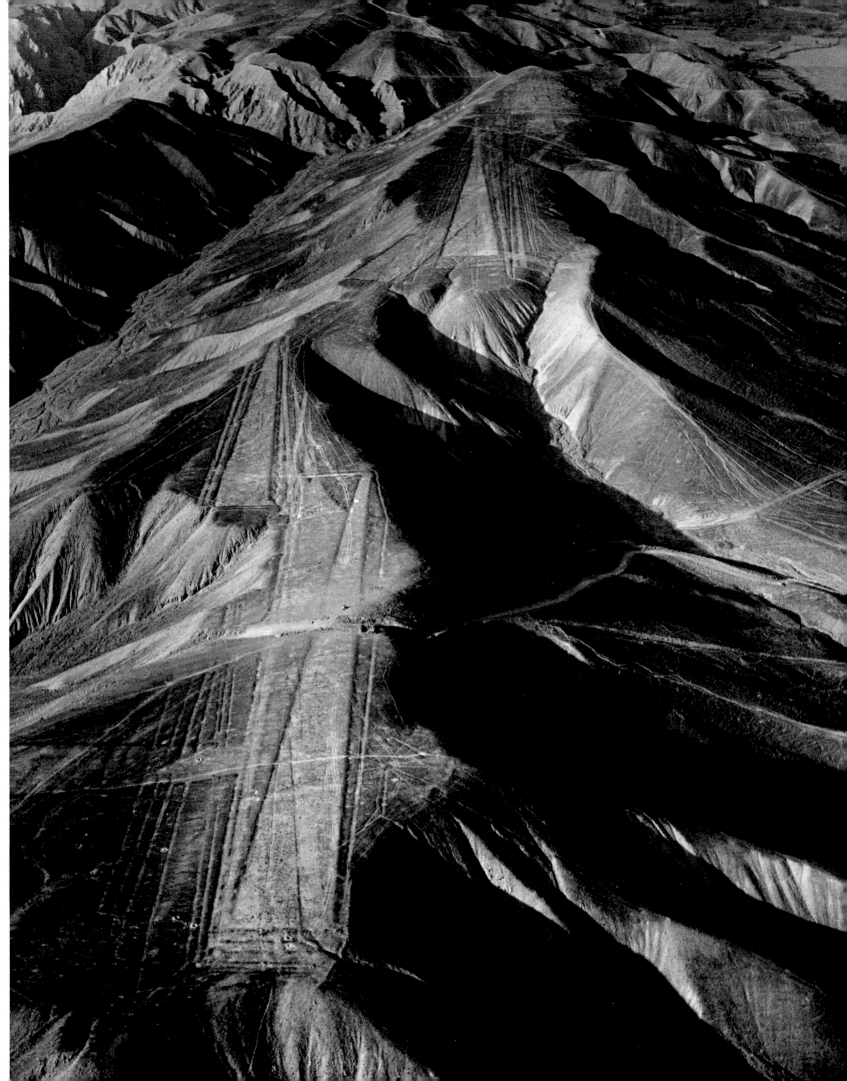

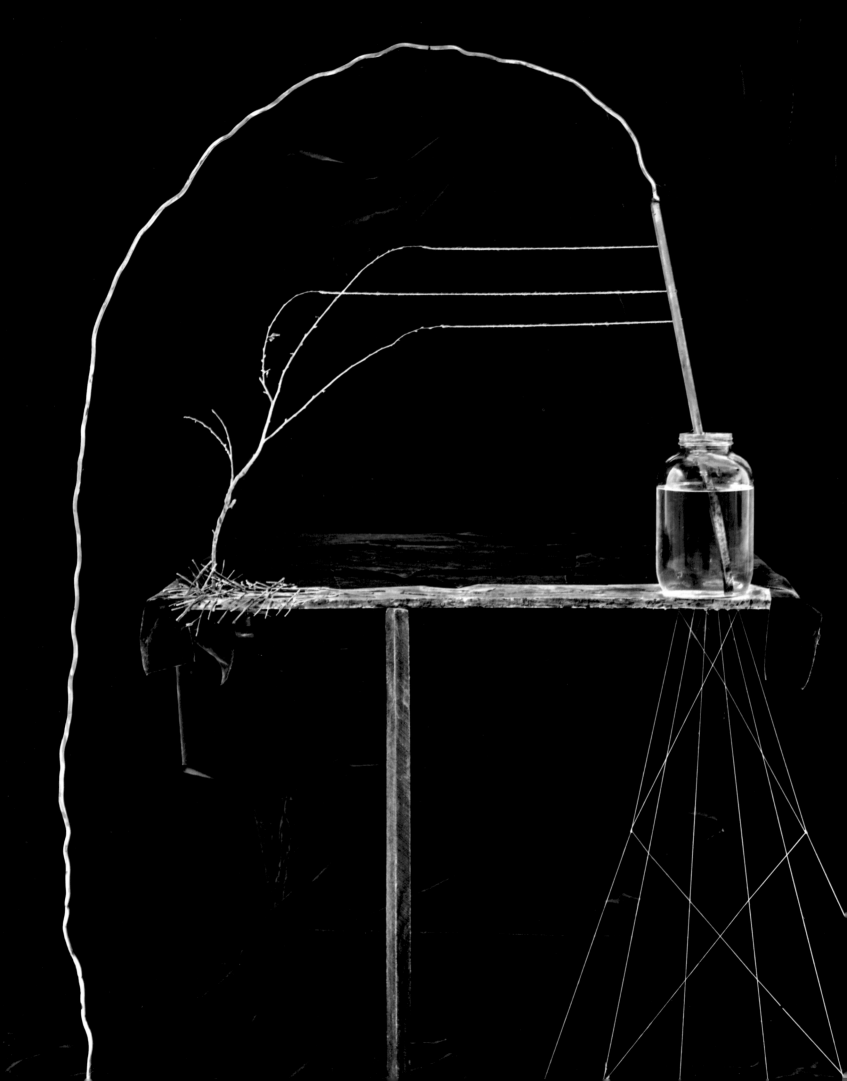

ZEKE BERMAN
Untitled (Jar and wire), 1987

A sensitivity to materials has generated aesthetics throughout my work. In making my photographs, materials affect imagery. For instance, I see the glue and string as being substantial line, and when I say substantial, I mean that word in an important way: appearing to have material substance.

The photographs seem to exist as photographs and drawings at the same time, and there is a sort of flickering between one and the other.

I hope that observers experience a kind of puzzlement, surprise, and under-

The photographs seem to exist as photographs and drawings at the same time, and there is a sort of flickering between one and the other.

standing, that people will reconstruct the picture as they are looking at it, and that there is some parallel between the perceptual experience of looking at my pictures and the cognitive process of constructing the world in general.

On the question of abstraction in my images, and whether the work is understandable, I feel it is important not to speak down to your observer, but to expect a lot of him or her, and to make work that is demanding. That seems to me a respectful, generous thing to do.

DOROTHY NORMAN *Telephone in Front of Stieglitz "Equivalent,"* An American Place, New York City, ca. 1940

When I was publisher and editor of the journal *Twice a Year*, we wanted to make people aware of themselves and of the dangers of war and of Hitler. We wanted people to see that their civil rights and civil liberties have to be protected and that we must enlarge our view from inside in order to understand the world around us.

Writing was a natural outcome of everything I cared about and did. And photography was the visual equivalent of that, of writing.

Not that much has changed. When I was working with Alfred Stieglitz, Paul Strand, Ansel Adams, and Eliot Porter, we prized a great tradition of beauty, meaning, and relationships. The greatest gift I received from Stieglitz was the gift of insight. I wasn't affected by his photography, as such. But in an overall sense, I was influenced by him because of his sensitivity and clear-sightedness and his great photographic gift.

DAVID WOJNAROWICZ
Untitled, 1991

All behind me are the friends that died; I'm breathing this air that they can't breathe; I'm seeing this ratty monkey in a cheap Mexican circus wearing a red and blue embroidered jacket and it's collecting coins and I can reach out and touch it like they can't. And time is now compressed; I joke and say that I feel I've taken out another six-month lease on this body of mine; on this vehicle of sound and motion, and every painting or photograph or film I make I make with the sense that it may be the last thing I do and so I try to pull everything in to the surface of that action. I work quickly now and feel there is no time for bullshit; cut straight to the heart of the senses and map it out as clearly as tools and growth allow. And in the better moments I can see my friends; vague transparencies of their faces maybe over my shoulder or superimposed on the surfaces of my eyes; thus I'm more aware of myself—seeing myself from a distance; seeing myself see others I can almost see my own breath see my internal organs functioning pump pumping; these days I see the edge of mortality; the edge of death and dying around everything like a warm halo of light sometimes dim sometimes irradiated—I see myself seeing death; it's like a transparent celluloid image of myself is accompanying myself everywhere I go. I see my friends and I see myself and I see breath coming from my lips and the plants are drinking it and I see breath coming from my chest and everything is fading; becoming a shadow that may disappear as the sun goes down.
(From *Tongues of Flame*, page 49.)

David Wojnarowicz died of AIDS on July 22, 1992.

SHOMEI TOMATSU
Time Stopped at 11:02, 1945, Nagasaki, 1961

It is impossible to exemplify all of my photographs with one photograph. However, by choosing one photograph, I can symbolically suggest one aspect of my understanding of photography.

The photograph I have chosen here is of a wristwatch that was stopped by the plutonium bomb dropped from an American B-29 over Nagasaki at 11:02 on August 9, 1945. The owner of this watch had the misfortune to be directly under the point where the bomb burst in midair at that hour of day, and died instantly, leaving a watch to record the time. I see a double meaning in this stopping of time. It makes one think about the reality of war and death and at the same time about the function of the camera. Because stopping the movement of time in an instant is the peculiar trick of photography as an expressive medium.
Translated from the Japanese.

JOEL-PETER WITKIN
Studio of the Painter:
Courbet, Paris, 1990

When people see my work, there is no
"gray area" of response. What they expe-
rience is either love or hate. People who
hate what I make hate me, too. They
must think I am a demon or some kind
of evil sorcerer. Those who understand
what I do appreciate the determination,

*These works are the measure of
my character, the transfiguration
of love and desire, and, finally,
the quality of my soul.*

love, and courage it takes to find wonder
and beauty in people who are considered
by society to be damaged, unclean, dys-
functional, or wretched.

My art is the way I perceive and define
life. It is sacred work, since what I make
are my prayers. These works are the mea-
sure of my character, the transfiguration
of love and desire, and, finally, the qual-
ity of my soul. With this work, I am
judged by myself, by my contemporaries,
and finally, by God. My life and work
are inseparable. It is all I have. It is
all I need.

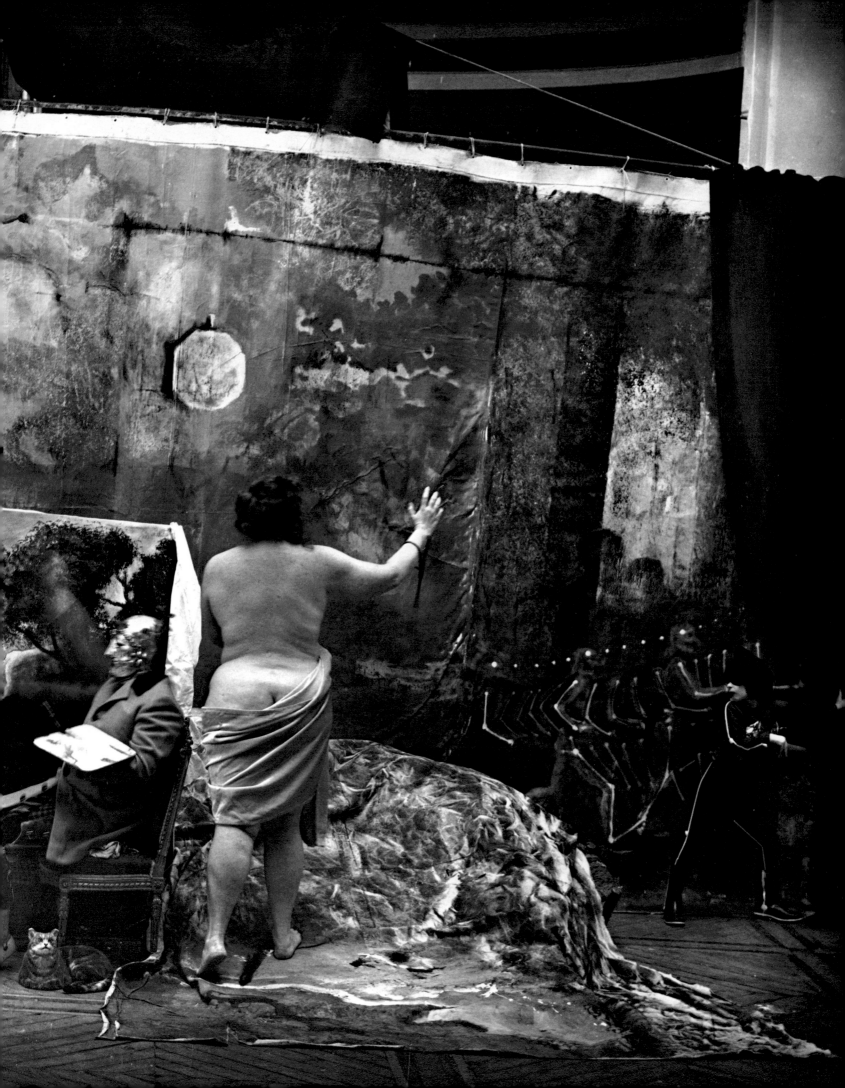

FORTY YEARS AFTER

the premiere issue of Aperture, *photographer Robert Adams interviews Michael E. Hoffman, publisher and editor since the 1960s. Hoffman speaks candidly about the early days with Minor White and Paul Strand and about the development of* Aperture.

ROBERT ADAMS: The poet Wilfred Owen observed, "Above all, I am not concerned with Poetry." You are quoted as having said to friends in a similarly surprising way that you are not interested in Photography. How are we to understand that statement?

MICHAEL E. HOFFMAN: Well, I think it goes back to my first experiences with Minor White and the community that he was involved with, which included Nancy Newhall and Beaumont Newhall, Dorothea Lange, and Ansel Adams, among others. What struck me upon meeting him was that he was able to live outside of the ordinary, that his focus was on being completely attentive, awake. For him, photography was a way to explore various levels of consciousness.

My interest in working with Minor was based, then, not on photography, but on the ways in which he transcended the mundane and achieved heightened levels of awareness.

RA: But didn't *Aperture* under Minor White begin with a commitment to photography as an art, carrying on the tradition of Alfred Stieglitz?

MEH: I don't think Stieglitz was primarily interested in photography as art. I think if you read Stieglitz's writings and if you attend to what he really was doing—when he was making the equivalents especially—he was trying to come in contact with a cosmic order, or a harmony.

RA: One thing that has puzzled me, though, about *Aperture* as it has evolved in recent years, is its inclusion of cacophonous work, of what seems in some cases to be journalism. *Aperture* seems to be dedicated to all forms of photography.

MEH: Exactly . . . but as Stieglitz would say, only when

they come in touch with qualities of the spirit. We are deeply committed to photojournalism when it has an altering effect on the viewer. The "Death of a Valley" issue brought together by Dorothea Lange and Pirkle Jones did not simply document the place and the individuals about to be overwhelmed by the creation of a dam. It magnified a sense of the quality of life that was being swept away. It made one ask important questions of oneself about real values. I have never been able to forget that issue as we experience more and more "progress." Perhaps the French term *photoreportage* has a more accurate feeling, but we are interested when the work takes on a significance larger than the immediate subject matter.

RA: Let's turn, if we may, to the early years of *Aperture* under Minor White, a period that you observed firsthand. Jonathan Green, who was an Associate Editor of *Aperture* from 1974 to '76, has written in his book *American Photography* that "through *Aperture*, White was looking for the Tao of Photography, the way to see clearly beyond the superficial, the intellectual, the pictorial." Does that seem a fair summary of White's goal, and does it remain the magazine's purpose?

MEH: Certainly Minor was influenced by Lao Tzu, and *The Tao of Painting* was an important work, which he used in his classes. He also used Richard Boleslavsky's *Acting the*

The first issue of Aperture, *1952; cover photograph by Dorothea Lange, Aspen, 1951*

First Six Lessons, and Eugene Herrigel's *Zen in the Art of Archery.* So he was very eclectic in using things that touched on experiences he felt to be important. He also used Evelyn Underhill's magnificent work, *Mysticism,* and Rudolf Arnheim's *Art and Visual Perception.*

He remembered the words of Saint Catherine of Siena, who wrote, "All the way to Heaven is Heaven, for he said 'I am the way.'" Minor was very much taken by that. It was his way of life, too. He was a true believer. He believed in the ineffable qualities, but also in the ability to realize them. He knew how hard it was, how difficult, and how painful.

Now, to get to your point. Was it Tao? Was it Zen? Was it Catholicism or the writings of George Gurdjieff? I think Minor felt strongly about all these perspectives. He felt that they were points of entry, pathways to qualities of light and of experience that were part of the rightful work of anybody attempting to explore in darkness.

Jonathan talks about Minor trying to go beyond the intellectual. If you read Minor's writings in *Aperture* over a twelve-year period, there's a lot of pretty strong intellectualization. He was a man attempting to work intensively with his intellectual apparatus.

RA: Green also notes that "in 1954, after only seven issues had been published, the founders [including Lange and Ansel Adams and Newhall] voted to discontinue the quarterly." But he goes on to explain that White got Shirley Burden's financial backing and carried on. Do you happen to know why the founders wanted to quit? Was it anything beyond the ever-present difficulty in finding money?

MEH: I have talked to several of them about this. Ansel used to laugh. He said nobody believed that *Aperture* was practical, that it could be done, financially or in any other way.

RA: Was each one of them contributing funds?

MEH: No. None of these people had financial resources. Ansel was the only one who really made a decent living. No, these were very dedicated people, but they didn't have the time or the energy or the belief, which Minor had, that this magazine could have a great effect.

What happened, I think, is that a letter was sent out to subscribers. There weren't very many of them at the time, but Shirley Burden was one of them, thanks to Dorothea

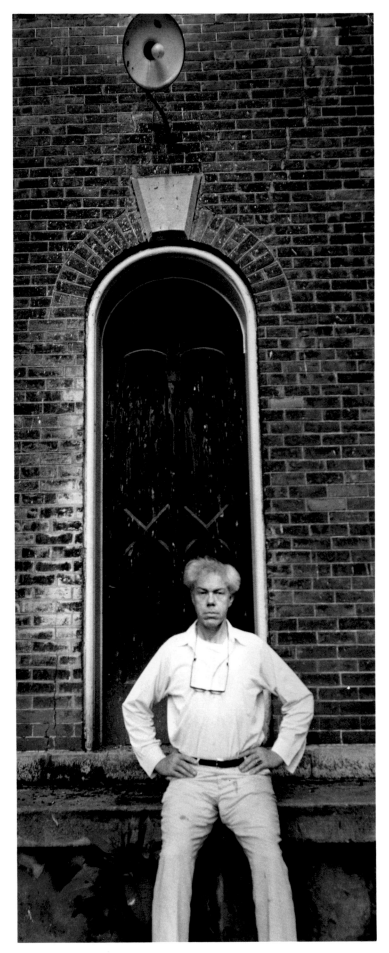

Minor White, Self-Portrait,
72 Union Street, Rochester, 1958

Lange, and he felt that it was really a tragedy that something of this quality wasn't continuing. So he flew up to San Francisco to meet Minor White. Minor, as Shirley recounted it, was living out of orange crates, which I believe, because when I knew him in Rochester, he was living in the most basic way. He had no money and no interest in having a lot of possessions.

Shirley asked Minor what he could do to help, and Minor said he needed $1,000 to get the next issue produced. Shirley said he would provide it, and that began a very strong connection. Although they were living a continent apart—Shirley didn't see Minor very much at all—Shirley made sure that the magazine continued until about 1964.

It was done with great love and great vision. Shirley was really an artist at heart, underappreciated, shy, very unassuming, and he never asked for anything. He was a remarkable individual, whom I loved and respected to an ever-increasing degree throughout our twenty-five-year association.

RA: In the first issue of the first volume of the magazine, in an opening statement about *Aperture* which is signed by White and Lange and all the rest, there is the following: "*Aperture* is intended to be a mature journal in which photographers can talk straight to each other." In the early issues, there is in fact a striking and exciting willingness by photographers and writers to address fundamental issues in clear language, issues like "What are we doing?" and "What is it good for?"

Do you have the sense that this directness is harder to come by now? And if so, why? And do you think there is any way around the increased academization of photography?

MEH: Think of Nancy Newhall. She was writing in a highly experiential, charged style. When you were near her and she was talking about photography and photographers, she *vibrated*. She was passionate. She was an intelligent, well-educated person who wrote beautifully.

DEATH OF A VALLEY

Aperture 8:3 *"Death of a Valley,"*
1960, by Dorothea Lange
and Pirkle Jones

I think at that time photography was life itself for people like her. They were in a process of discovery that was enormously exciting. There was no monetary support, there was no real outside interest. They were very much on their own.

What has happened today is that the academic side has overwhelmed the experiential side. A great many people have become interested in photography, but without bring-

My interest in working with Minor [White] was based, then, not on photography, but on the ways in which he transcended the mundane and achieved heightened levels of awareness.

ing to it the qualities of engagement that force one to ask those primary questions. Instead, we get questions about style, and we get art-speak.

I don't read much current criticism. I have never been interested in much of the academic approach. But I do feel that there is a tremendous change from those years, when many of the writers and curators were vitally and directly engaged. There was a personal interaction and a sense of personal responsibility.

RA: One of the sections that was particularly lively in the early issues—sometimes even explosive—was the letters section. Has there ever been any thought of bringing that back?

MEH: We have wanted to, but we have rarely received the kind of letters that Minor got in the fifties. For example, I know that when Minor published some Frederick Sommer photographs, which included one of an amputated foot, there was a Catholic nun who wrote a wonderful letter about the integrity of the body, and how the photograph seemed to denigrate a sense of the holiness of the body. And Minor responded. It was an important dialogue. I think in the end the Sommer photograph prevailed.

One of the recent issues that provoked a great many letters was "The Body in Question." Some of the letters were interesting, but more frequently they just called the editor of that issue a pornographer, or canceled a subscription. The letter writers didn't seem to want to initiate a dialogue.

But if we were to receive letters that encouraged a dia-

logue, we would definitely try to publish them.

RA: Where and when did you first meet Minor White? And as you came to know him, what was it that most convinced you to shape your own life as you have—you've been working with *Aperture* since 1964. Was it his manner, or what he said, or his pictures, or all of this together?

MEH: I had been given a subscription to *Aperture* in 1957, when I was fifteen years old. At first, the magazine had no effect on me. Then, all of a sudden, one day I sat down to look at it, and three hours later I came back changed. I had never had such an experience of total immersion. It was the issue that Nancy Newhall had done on Edward Weston, at Weston's death, called "The Flame of Recognition."

RA: Had you yourself been photographing?

MEH: Yes. I had been taking pictures for about seven years. As a result of my *Aperture* subscription, I received a notice that Minor White was giving a workshop in Denver. I had just come back from college, and I said to myself, "This is something I could do."

When I arrived at the workshop, I found it to be quite a bohemian setting. In the room there was a tall man with a beard, rather handsome, rather formidable—and I was sure that he had to be Minor White. To the right of the door there was another man with an open white shirt and some loose-fitting trousers. He had one leg up against the wall, and I think he was wearing sandals. I said to myself, "I wish this man would leave as soon as possible, because what the hell is he standing around here for? Why not get on with this important undertaking?" Of course, the man in the white shirt was Minor White.

I had never encountered a presence like his, somebody who was so unassuming, who had a relaxed, gracious manner, who was incredibly accepting of the people in the

NOTES TO A VISUAL EDITORIAL

Foreseeing gentle protests from photographers who claim that they can not stand words with photographs (and who can not understand photographs without words) we append here a verbalization of the visual editorial in this issue entitled Beyond Art.

Vocalizers often say that there is no such thing as art, only artists. On the opposite side of this coin are the members of museum personnel who say that there are no such things as artists, only art. The situation is perennial, never to be resolved any more than the eternal problem of the law. There are no cops without robbers, no criminals without judges.

If one is interested in solutions to problems, perhaps a way is found beyond art. One way is to take the path of business and pay two million dollars for some yardage of famous pigment on canvas. This investment-way beyond art is fully publicized. A quieter road avoids cymbals of greatness, the masters, the amateurs (beginners and lovers alike). To anyone acquainted with the world of art and photojournalism, avoidance or escape from businessism, greatnessism, amateurism, masterism, professionalism, academicism, and hypnotism seems to leave but a small crack, if any, by which to go beyond art. But a chink is enough. To the professionals who must promote the myth that art is man's highest form of achievement, to even think that a possibility exists of a way beyond art is unthinkable. Stieglitz erased the myth, at least for himself, when he wrote that there is no such thing as art, only artists. (Doubtless someone in the psychology of the criminal professions has written that there is no such thing as cops, only robbers.)

General Semantics: deals with rewording ourselves out of habitual ruts of thinking. So it can provide at least a temporary way of locating the chink in the cast iron fence of art that some wish to get beyond. The habitual rut is symbolized by those who treat the photograph as the final product of a long series of mental and psyche states ending in an euphora of self love. For example the photograph that wins prize or praise for all the wrong reasons.

To rephrase for effective change, according to General Semantics discipline, we get this: Camerawork: or photography in service of intensified consciousness. That is, Seeing is more important than our pictures when it leads to Vision.

The opposite of this is art. None other than British Art Historian Sir Kenneth Clark writes that art is the opiate of an elite. Beyond art, Camerawork points to Light and Vision. Vision based on understanding, in flashes, the ugly nature of man, his horrifying place in the large scheme of things and laws—and a way out—light. Beyond art relates to an earned freedom from Karma, as the East Indians say, as opposed to an "escape" by a refusal to See—by a retreat into the blindness called beauty.

Beyond art covers the entire phenomena of photographing. The residue left in Rogovin of Spirit that he encountered photographing in Negro churches. . .

The photograph on this page functioned for three persons viewing it—One with an inner mask about to drop, suddenly was frightened because he saw a thing of beauty, the curtain, ripped down. This marked the beginning of a growing understanding within his own realities. Another, recently married, turned a radiant face and said, "Now I understand what love is." The third, "the first time that I ever saw a window sill daydreaming." The photo, made in a cloud of unknowing, has since served to intensify my own awareness. Such is the "meaning" of the visual editorial.

Minor White

Photograph by Minor White
from Aperture 10:2, 1962

workshop, and who appeared to radiate a quality of light. Minor had a rather deep voice and a great presence. He gave us assignments that embarrassed me: we were to stand out on a street corner, for example, and let all the traffic and the people just go by. Just stand there. A lot of what we did, I only later came to understand, were the kinds of exercises that certain religious communities utilize to train people to become more aware, more present.

At one point we even went out to a garbage dump to start photographing. I thought, this is the limit, this is the end. I was going to give it up right there, and then things began to transform themselves before my eyes. I was astonished. We processed and printed every day, and then we had sessions so that we could look at what other people were doing. It was an intensification of what I had experienced with Weston's "Flame of Recognition." The search seemed somehow to give life real meaning, and Minor was both a guide and an ally.

RA: How did you then get to know White better?

MEH: Well, I tried to suggest to him that I could be help-ful in the workshops that he was doing in the East. I was fishing, trying to find something. He was not very open to working with anybody. He was a very private person. In any event, he did agree to let me set up a workshop at the Millbrook School, a secondary boarding school I had attended. This was very successful, and so he agreed to give a workshop at St. Lawrence University. And then, in 1964, when I graduated, he invited me to Rochester to work with him personally, which I considered a great opportunity.

Aperture had gone out of existence in early 1964, and I said to Minor that I thought it should continue. And then I met Nancy Newhall, who was very supportive, although I suspect that Minor really didn't want to see *Aperture* continue.

RA: Why was that?

MEH: He felt that he had done everything that needed doing. *Aperture*'s lifetime, then, was almost equal to the span of time during which Alfred Stieglitz's *Camera Work* was published—Minor felt a very great connection with Stieglitz—and he thought *Aperture* had come to its natural end. He also was tired of the personal attacks, the lack of support, and the isolation. He had worked without any monetary compensation. He had devoted twelve years to the magazine, and had no money except what he earned as a part-time instructor. Minor eventually agreed, and Nancy and I decided we would do an issue on Weston, because the 1958 "Flame of Recognition" issue had reached only a few people. We decided to redo it simulta-neously as a book and as the first new issue of the maga-zine, which had been dormant for almost a year. We had no money at all, and for a number of years I received no compensation.

RA: How did you manage?

MEH: I had a small army pension, and my father, although not a wealthy man, was generous and support-ive, and he paid my rent. I had also met an extraordinary woman, Katharine Carter, at one of Minor's workshops. She and I found we had a bond, and we lived together and shared expenses. Later we were married. So we were able to survive, until we could build other sources of income.

Aperture, in all those years, never provided an ade-quate livelihood—to me, anyway. And my needs were fairly modest. So I set up a book-distribution company with other presses, and then also worked with the Philadelphia Museum of Art, and somehow, with all of these things, it was possible to survive.

RA: What was the distribution company? Did it dis-tribute just photographic books?

MEH: No. It was a consortium of avant-garde presses. In addition to Aperture, it included Something Else Press, run by Dick Higgins, which published concrete poetry, and work by the artists involved with Happenings and Fluxus, among other things. There was also Corinth Books, which published the Beats; and The Jargon Society, directed by Jonathan Williams, who was involved with *Aperture* long before I was and is a man of unique literary perceptions with connections to photography.

So we were interested in a broad cultural reach. I think what was important about this, Bob, is that it was a time when the arts communicated with each other. The Living Theatre, John Cage, Merce Cunningham . . . there was a feeling of community in the broadest sense. We also worked with the Frontier Press, which was publishing Charles Olson and Ed Dorn, as well as with Eakins Press. It was a magical time in that sense. It was also a hard time. There was no support. But by getting together, working together, we were able to support each other.

And I think that again goes back to what Aperture was all about, and what has often been lost sight of. This consortium brought Aperture from almost no distribution to the point where it was distributing $2 million worth of books a year. We were just beginning to break even at that time. We were paying very modest salaries. But we were able to maintain our resources. The distribution company stopped in 1980. Aperture then looked for distribution elsewhere. The book business changed and many small presses couldn't survive. But it was a very interesting time.

RA: How was Aperture surviving financially?

MEH: With the publication of the new Weston issue, we realized—I realized, anyway—that we couldn't go on as Minor had done, with so few subscribers. The preparation costs and all the rest were much too daunting. We had to spread the costs among a larger audience. So I figured that we had to produce 13,000 copies, both for potential subscribers and for sale in book stores. You have to remember that when Aperture ended in 1964, I think the quarterly had five hundred subscribers. When I went to the accountant later that year, he said, "Aperture is bankrupt. You have no money, and you owe $25,000." It was a shock; $25,000 seemed like a fortune.

I also had a sense, as I suggested earlier, that in some ways Minor didn't want me to succeed. With all of his wonderful qualities, he needed to keep control over everything himself, and if he didn't, he wasn't so sure that he

wanted to see it happen. He was much more the creator than the editor, and that's what really made Aperture valuable and interesting for him.

RA: Did White change toward the end of his life? Did he become, as he sometimes seems when I read about him, self-absorbed and humorless, in spite of his selflessness? Green writes, for example, that "On his deathbed, a few moments before his heart stopped, White asked his last visitor, 'Do you have any questions?'" That could be the exit line for a saint or a jackass, and I assume, since he was human, it's a little of both. But it seems a long way from the White that is quoted early on. Did he change?

MEH: Well, I wasn't there, and I don't know the context of his saying that, and I think one would need to know. But I think when he asked "Do you have any questions?" he was being consistent with his work in the Gurdjieff

In the early issues, there is in fact a striking and exciting willingness by photographers and writers to address fundamental issues in clear language, issues like "What are we doing?" and "What is it good for?"

process. I think it was a creative gesture on his part; in other words: Do you have any questions of me as I am leaving the world? Is there anything that you would deem meaningful or anything that I can say that would be useful? I think it was a generous position on his part rather than anything else. That would be consistent with his way of being with people.

Now, let me go back to what you were saying about his changing. Yes, he did. But it was not a question of his character; it was a question of his physical life. In 1967 he had a very severe heart attack. He was given little time to live. He was given three months by the doctors, who said he had to have surgery, which he refused. Instead, he went to a psychic healer and to another man who helped to enhance his physical well-being. These two people worked with Minor over a period of years, and really gave him nine more years of life.

He changed drastically. He lost 30 or 40 percent of his body weight. He had to do radical therapy, and made a complete change in his diet. He was living on a thin line.

Minor White sequencing photographs; photograph by George Peet

That certainly affected his outgoingness. But I think the spirit was still there.

As for my relationship with Minor, he and I had the same astrological sign. We were born within a few days of each other. And he was a great believer in astrology. This didn't make it easy, because we were both Cancers and would tend to lock claws, so to speak. But I think underneath it, there was a great deal of respect—especially because when he went out to other people to publish his work, and all kinds of people promised to do it, nobody did. Finally, I said, "I am going to publish your *Mirrors/ Messages/Manifestations*, if it kills us!" And everybody said it would. It was enormously expensive to do.

Steve Baron had also studied with Minor, and had been working with me on production at Aperture. He and I basically did this book together. Steve was and is a brilliant production person, and I think a rather amazing human being. He's a great friend, who has been connected with Aperture for almost twenty-eight years now. At any rate, *Mirrors* came out, and it was successful. It was a miracle.

RA: Financially successful?

MEH: No, but at least it didn't truly kill us. Although it never recouped the investment, we did get enough back to pay the bills, more or less, over a period of years. Around that time, we also did "Light 7"; "Octave of Prayer"; "Be-ing Without Clothes"; and "Celebrations," four remarkable *Aperture* issues that Minor put together at M.I.T. with my help. For Minor, these were a fulfillment of what he believed was important regarding the sequencing of photographs and the bringing together of a broad range of people to explore a meaningful idea or visual thesis.

By this time, we had also revolutionized the production

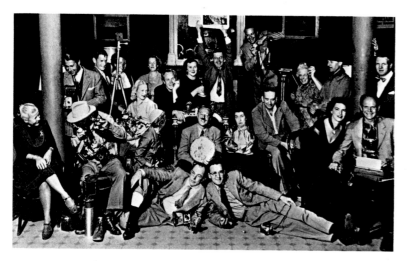

Aspen Conference where Aperture *was conceived; pictured are the founders, including Minor White, Ansel Adams, Barbara Morgan, Nancy Newhall, Beaumont Newhall, and others, 1951; photograph by Ferenc Berko*

process. You see, Minor had initially been printing with letter press, and it was impossible to continue printing four pages at a time, using 150-line-screen, steel-faced copper engravings.

So in 1966 or 1967, Steve Baron and I started working with Sidney Rapoport using something called "stone-tone" lithography. We worked twenty-four-hour days, day after day, week after week, in an attempt to create a process that would produce magnificent two-color images on a lithographic press. It had only been done once successfully—with a Harry Callahan book—and it was not yet commercially feasible. We really felt the only way we could continue was to perfect the process.

Minor saw all of this, and was quite amazed. It gave him more confidence, and that's when he really began to collaborate, around 1967 or '68, with the issues I mentioned. In the previous years he had resisted, and I was pretty much entirely on my own, starting from scratch.

RA: Did White offer judgments on issues as they went along?

MEH: Yes. He was extremely acute—one of the greatest picture editors of all time. He believed you could not will things into existence. You had to work on yourself so that you became available for things to happen. He was a great believer that there were graces with which one had to make contact.

RA: Why don't we talk for a little about *Aperture* the magazine as it has evolved since White gave up his guidance of it. In recent years, there has been a shift away from issues of mixed content to issues that focus on a particular theme, and some people—I think particularly photographers—have found that the results are often less interesting to them. They point out that the thematic issues sometimes seem to begin from an idea rather than from pictures in hand, and thus, perhaps inevitably, are not as exciting visually. Photographers also would suggest, I think, that these thematic issues have tended to discourage submissions of general portfolios. This may in turn be why the magazine doesn't seem to have as many wonderful, anomalous shots, sometimes by unknown photographers, which made some of the earlier issues of the magazine so exciting.

I am interested to know how you see the pros and cons of running a schedule of thematic issues, and interested to

know if the practice is one that you think is valuable enough to continue.

MEH: Well, to begin with, I think the theme idea was a predominant mode in Minor's approach to the issues in the early years. As *Aperture* evolved, and because of the editors—Carole Kismaric, Larry Frascella, Mark Holborn, Nan Richardson, Chuck Hagen, all of whom are very talented, as is our current group: Rebecca Busselle, Melissa Harris, and Andrew Wilkes—there was a desire to create a more coherent framework. I think it was a reaction to the portfolio approach, which seemed quite uncreative.

A great many people have become interested in photography, but without bringing to it the qualities of engagement that force one to ask those primary questions. Instead, we get questions about style, and we get art-speak.

There was no sense of a larger vision, a larger idea with which the pictures had to interrelate, by which they had to be challenged. I think that there was a desire among the editors to touch on ideas beyond those possible in a portfolio approach. In other words, larger ideas into which photography could focus and give a larger meaning, gain a larger meaning.

If you take the "Beyond Wilderness" issue, edited by Chuck Hagen, for instance, I think that's really quite successful. This issue was a way to bring in a broad variety of images, by many people, and to show how these works related to each other.

So a preference for portfolios seems to me to reflect photographers' understandable desire to see their own work magnified, but we'd rather work toward what is essentially a community process. Although, on the other hand, I do think there's some legitimacy to the criticism. Melissa Harris, who is the magazine's senior editor now, feels strongly about a more magazine-like approach, as does Andrew Wilkes, who edits a number of our books each year. Melissa is oriented toward a broad variety of material, and moving away to some extent from the solely thematic approach, while still maintaining a sense of community. I think she'd like to run one or two portfolios in each issue that have nothing to do with the given theme.

Her position, I think, is that we see some interesting work that is not necessarily appropriate for a book, but that will also never fit one of our themes. So there clearly is a change in point of view. We may be nearing a time when we won't continue with thematic issues.

RA: You're dependent on what photographers do.

MEH: Exactly.

RA: How does an issue originate? For example, does the idea usually come from in-house? And then what is the editorial process that leads to the choice of an issue's theme?

MEH: We wrestle with that question all the time. We've been blessed over the years in having some very creative people involved with *Aperture*, all with very different views.

Chuck Hagen, for instance, wanted to do a show called "Drawing and Photography." And he was deeply committed to the idea of doing this as an issue of the magazine as well. I think it was a marvelous exploration. It was really a chance to explore the medium in a broad variety of ways. Four issues before that, Melissa Harris did "The Body in Question." In between, Andrew Wilkes edited "The Idealizing Vision," on fashion photography; then there was the issue on German photography, and "Connoisseurs and Collections." These were very diverse, equally valid approaches to photography and the magazine.

The hope is that in four issues we are able to cover enough ground and to include enough photographers to satisfy the need for people to be shown. But we really rely on the creative juices of the editors. We just did an issue called "Our Town," which includes photographs by a broad variety of remarkable photographers, many of whom are not known, and marvelous texts by David Byrne, Richard Ford, Michele Wallace, Gary Indiana, John Waters, Marianne Wiggins, and others. We hope that this is a way to engage photographers, but also to achieve a broad cultural reach. We try to bring in a variety of forces of our time.

RA: Is there a formal editorial review that goes on?

MEH: Yes.

RA: Do you meet each week?

MEH: No. It's not done by committee. We have a general portfolio review once a week—for people who just submit work cold—but in terms of the picture selection for the

issues, a great deal of authority is given to the editor, along with our design director, Wendy Byrne, who has been with us for more than twenty years, and is very acute in this area. We've also brought in one of the most inventive designers in the country, Yolanda Cuomo, and her talented associate, Trey Speegle. They really have a wonderful sense of imagery and design. So this is a collaboration that goes on. I've been involved with picture editing of the magazine for many years too, and I play a role in trying to make a mess of all the good work these editors are doing, asking questions, disrupting things, changing things around, and trying to see what happens in the process—all to test out the ideas. We are always testing the material and the approach.

RA: I want to ask you a little bit more about issues of the magazine that have raised questions. There have been a number of issues devoted to specific regions—issues on German photography, British, Russian, Japanese, Latin American photography. I am curious about how these are edited in order to get a true representation. For instance, some important photographers were not included in the issue on Germany. Why is that?

MEH: Well, I don't know. There was an incredible search done in Germany and elsewhere in an attempt to locate the most important photographers working in Germany. There was also an advisory board of knowledgeable people.

RA: Many photographers, I think, found the issue on collectors depressing, with the exception of the wonderful piece on Dorothy Norman, which seemed to speak from a healthier, sunnier age. Do you think that it was an accurate picture of collecting now? And might the issue properly have included some more obscure, less power-hungry, less watchful-of-fashion example of a small collector?

MEH: I don't really know. I think that you can't do everything in an issue, and still maintain its focus. The attempt was to show the broad range of tastes and ability, connoisseurship or lack of it, ego or lack of it, in five or six totally dif-ferent individuals. I think if they hadn't collected in-depth, if they hadn't lived it to some degree, which lesser collectors often don't, then the issue would have been unpublishable. It would have seemed inconsequential. As for Dorothy Norman, you have to remember that she never saw herself as a collector.

RA: Which is the beauty of it.

MEH: And hers was part of the range of attitudes we wanted to examine. You take somebody like Thomas Walther: here is a man who has one of the most extraordinary collections, one that is highly individualistic and is created from reflection and discernment, and to which he has given his life. And then there is a person like Stanley

We are at our best when the text offers significant entry points that coexist with the photographs, rather than simply explaining them.

Burns, whose collecting is very ego-driven. He is unyielding in his belief that he sees, perhaps creates, masterpieces by the power of selection where no one else is looking. So it's interesting.

RA: You've already mentioned "The Body in Question," which included fairly explicit sexual material. Did it cost or gain *Aperture* readership and financial support?

MEH: That's really tough. I would say that it gained us credibility in an area of the arts in which very serious work is being accomplished, where people are attempting to contend with some of the powerful forces at work in this country—if those forces had their way, it would mean that we would perhaps be seeing only Norman Rockwell. We received support from a lot of the press, except for the *Wall Street Journal*. On the other hand, our mailing house quit in reaction to the issue, and as I mentioned before, we had some strong complaints. At the Colorado Mountain College, a professor canceled the college's subscription and wrote us a vituperative letter. I wrote back, and I also sent a copy to the dean of the college, asking him if the teacher had the authority to speak for the entire student body and the faculty in canceling the subscription. It turned out he didn't, and we received a renewal from the president of the college, together with a letter saying that he might not always agree with what we were doing, but he felt that

Aperture 14:1, *"Light 7,"*
cover photograph by
Hine Gravenhorst, undated

it was important to do it and to make it available to the students.

That's pretty much what happened with most of the complaints. When we got people really to look at the issue, they saw it was relevant, they saw that we were not being prurient, and we were putting the material out there so that the important questions could be asked. Although Melissa clearly had a very strong point of view, we certainly didn't have the answers. We did know, however, that David Wojnarowicz was a great artist, and we knew that his work shouldn't be stopped. We knew Karen Finley, no matter how disconcerting her performance work may be for some, is a great artist, who is of our time, and who is asking shrill and difficult and painful questions. And these are the people we want to publish.

RA: When an issue that deserves to be published is potentially inflammatory, is the Board of Trustees consulted? Is that where the final say resides?

MEH: No. The Board is made up of some very creative people who would never censor what we do. We have to show reasonable caution not to violate any laws, and we have the generous help of an attorney, one of the best First Amendment lawyers in the country, Burton Joseph in Chicago, who has contributed his services to Aperture for years. And so we consult him when we publish work that could create problems in relation to the various laws of the land. He does not engage in any censorship, which is very important to the way Aperture operates.

RA: Have any of the thematic issues originated from somebody wholly outside the Aperture staff?

MEH: Ideas are gathered from a broad range of creative people. People from outside Aperture are always being consulted. We are open to collaboration and guest editors. When Rebecca Busselle did the Haiti issue, she went to Haiti and immersed herself in the place. Because of its sociopolitical relevance, as well as the photographic and literary attention paid to it, Haiti came to us as a focus for an issue. At that time, she was not working at Aperture, although now she is.

RA: In an early issue, White ran material on the zone system, presumably because technical skill is normally required to reach aesthetic ends. Would the magazine be open to some kind of nuts-and-bolts issue?

MEH: I think we would need a nuts-and-bolts editor to

deal with it. But I think it's a good idea. I think it would be interesting to a lot of people.

RA: Would you have any guess as to how many unsolicited submissions the magazine gets?

MEH: It's an enormous number. I think that we get about twenty submissions a week.

RA: Are writers and photographers paid?

MEH: Aperture is nonprofit, and for many years, nobody was paid to do anything. That isn't true any more, because people couldn't survive. But staff pay is modest. And production costs are high. The magazine loses about $100,000 a year before contributions, which is a preface to saying that if we were to start paying photographers, we could not continue publishing.

The reason that photographers have graciously provided their material free—at least we've been told this—is that, one, it's treated with great respect; two, it reaches a large public; and three, in many cases it has sold work for the photographers that would not have been sold otherwise. Also relevant is the fact that we never commission work for the magazine. If we were to do this, we'd have to pay the photographers. We certainly don't want to take advantage of photographers, or exploit them. Right now, we generally only pay if they incur special expenses—if we ask them to make a better quality print for reproduction, for example. Needless to say, I wish we could pay everybody all the time. Most of the photographers realize what we're up against, however, and that we are providing a service to them.

Carole Kismaric, former director of publications, and Michael E. Hoffman, executive director, ca. 1983

The writers don't get the same benefit, and they are creating something specifically for our publication, which the photographers are not doing. We do pay the writers, although I must add, they are paid rather modestly.

RA: The writing in *Aperture* is uneven, but it's also arguably better than in most art magazines. The list of people who have written for *Aperture* is remarkable—Reynolds Price, Guy Davenport, Barry Lopez, and others. Sometimes, however, it does seem there is writing when it's not needed, when pictures are eloquent enough in their own terms.

MEH: We are at our best when the text offers significant entry points that coexist with the photographs, rather than simply explaining them.

RA: The poet C. Day Lewis wrote that "The critic has one pre-eminent task, the task of easing or widening or deepening our response." Who do you find currently to be the most successful at easing or widening or deepening your response to photographs? Who are the commentators that you read?

MEH: I often find that the people who bring the greatest illumination for me to the whole photographic process are those who are not primarily writing about photography. For instance, Barry Lopez's *Arctic Dreams* is one of the most photographic books I've ever read.

RA: I think so too. It's extraordinary about landscape—about light and space.

Michael, you are widely respected by those with whom you've worked for your gifts in hanging photographic exhibitions. Do you take an active part in the layout and design of the magazine, along with Wendy Byrne and others?

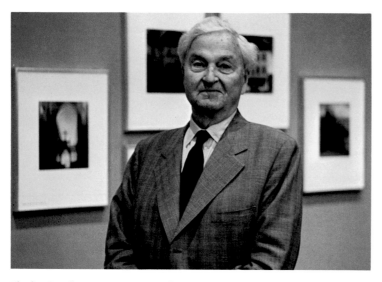

Shirley Burden in Aperture's gallery, named in his honor, 20 East 23rd Street, New York, ca. 1986

MEH: Yes.

RA: So that's something I can go ahead and quiz you about. *Aperture*, like *Life* magazine, sometimes runs pictures across the gutter. Since a photographer almost never envisions a picture that way, why does *Aperture* do it? I have to tell you that I have never known a photographer who didn't see the practice as rape.

MEH: The magazine format is very limiting, especially with horizontal images, because pictures must usually be reproduced at a fraction of their optimum size as photographic prints. Beyond that, to be able to build a dynamic design, to be able really to give the full impact of certain images, you need to be less precious, more daring.

One of the things that happens in a magazine if all of the images are the same size or a similar size is that it becomes very hard to look at them all with the same degree of intensity. You've got to have pacing, you've got to have drama. Hans Georg Pospospchil, the superb art director of the *Frankfurter Allgemeine Zeitung*, said, "You've got to design a magazine like a tidal experience." It has to have moments where the waves get high, and there have to be troughs and all of the rest. You cannot design a magazine successfully without countervailing elements in tension.

RA: Inasmuch as monographs are sometimes published as issues of the magazine, in keeping with Aperture's history, and given that both the book program and the magazine are staffed to some degree by the same people, I'd like to ask you now about Aperture's book publishing. Do you have any idea how many books have been published under your leadership?

MEH: Most likely about three hundred.

RA: It must be the largest photographic book list in the world.

MEH: I don't know if that's good or bad. It worries me.

RA: How many unsolicited book proposals do you get in a year?

MEH: Oh, I guess maybe a hundred and fifty.

RA: Do they usually arrive fully developed with a maquette, or . . . ?

MEH: Every possible way.

RA: How are Aperture books financed?

MEH: Let me try to explain. We have been accused of saying that photographers have to raise money for their own books, which is not true. Yes, we ask for their collab-

oration in helping us to raise the subsidy; no, we don't ask them to write us a check. This is not vanity publishing. The fact of the matter is that we only attempt to raise enough money to cover what Aperture will lose if we sell 80 percent of the books printed. This subsidy is only a modest percentage of what it actually costs us to make the books. We attempt to raise the subsidy—from foundations, corporations, individuals—so that we can at least break even on the books if we sell them. Implicit in this is a great risk, because if we sell less than 80 or 90 percent, we're going to lose our shirts—and we do sometimes.

So what happens is that we always have to start from scratch. There is never any money left over from a prior book to support a new book. For all of these years, we have said, "If we can just break even, it's okay." The goals have been to keep the price down and the quality at the highest level, and to ensure the widest possible distribution. Recently, we haven't been able to break even.

RA: What have been the best-sellers on Aperture's list?

MEH: The Diane Arbus monograph; Edward Weston's *The Flame of Recognition*; Edward Curtis's *North American Indians*; W. Eugene Smith's monograph.

RA: How many books have been sold?

MEH: The Arbus is getting up there in the 250,000 to 300,000 range. *The Flame of Recognition* sold well over 200,000, and Curtis's *North American Indians* sold over 100,000 copies. Gene Smith's monograph sold about 90,000 copies.

RA: Has Aperture ever considered producing and marketing videotapes?

MEH: Yes, we have. It's a good idea, but we're overcommitted and have a small staff. We'd love to figure out a way to do it, and some day we will.

RA: Could you talk a little about the Strand Archive? Is it a repository of just his work? What is there? Is it a study center?

MEH: The Paul Strand Archive contains approximately 3,500 prints made by Paul Strand. It contains about 4,500 original negatives, everything from his lantern slides made from 1912 to 1917, to his 10-by-13-inch glass plates that he used for contact prints, to all of the negatives—2 1/4-inch, 4-by-5-inch, 5-by-7-inch, 8-by-10-inch—that he made throughout his life. It also contains prints of his motion pictures, as well as his library.

The archive has been concentrating on cataloguing and preserving this material, and has focused on disseminating a small number of the most important original and vintage prints, primarily to institutions. We will be completing this process in the next few years.

But we need to determine what the future of the archive will be. How can it be made more accessible to the public? Now you have to make an appointment and you have to go to Lakeville, Connecticut to see the work. We have to consider how it will be used in the future. Strand took the position that this material should not simply be given away. He felt that when material was given to museums and they didn't have a financial commitment to it, they didn't appreciate it. It is a truth that has been proven more than once.

RA: Are there any plans to do restrikes from some of the negatives?

MEH: No, we won't do that.

RA: What is the Photogravure Workshop? Is it an actual place? Is it more than one person?

MEH: The Photogravure Workshop was begun by Aperture in the seventies, after Strand's death, to fulfill Strand's hope that photographs could be reproduced by hand-pulled photogravure.

I was asked by Steichen, after he saw the second edition of Strand's *Mexican Portfolio*, to do a gravure portfolio of his work, and the creation of the Photogravure Workshop came about in my efforts to find a way to print Steichen's negatives.

I met Jon Goodman, and we began the process of building our own gravure press in Millerton, with a brilliant local machinist, using Swiss plans. We started the workshop in the basement of Hazel Strand's house. Jon worked with Richard Benson for a couple of years, and we really redeveloped the process so that it was superior to the way it had been used until its demise in the thirties.

That workshop then moved to North Hadley, Massachusetts, so that Jon could be part of a community of

APERTURE

Aperture 77, 1976;
*cover photograph
by Josef Koudelka,
from the series "Gypsies," 1975*

printers and bookbinders. Aperture still maintains a strong connection with it. Jon runs it as an autonomous activity now. But we continue to produce gravures.

So the Gravure Workshop is still a very important part of our little universe. Jon has done some beautiful portfolios for Robert Mapplethorpe and for other people. I think it's a very important activity and Jon is a distinguished artist and craftsman.

RA: The Burden Gallery is still in operation. Is it a commercial gallery?

MEH: No. The Burden Gallery was the dream of Shirley Burden, and he provided the funding during his lifetime to cover the basic costs of maintaining it. We had to provide additional money for the shows, which came from our small endowment. Then as now, it was very hard for us to raise outside funds, although the New York State Council

Few people ever get to see an original Strand print close up. As soon as there is glass on it, as soon as there is only low-level lighting, which museums now require, you cannot see Strand's work. It has so many layers.

on the Arts provided some modest backing, as did some individuals. Now the gallery does shows when we can raise the money for them. Last fall, we did the Nick Waplington show, which then traveled to the Philadelphia Museum of Art. After that, we showed Donna Ferrato's pictures, which correspond to our book *Living with the Enemy*, and then an exhibition of Maggie Steber's Haiti work. We'll do an exhibition around the "Our Town" issue of the magazine in the fall of 1992, then our 40th Anniversary show, and then we hope to do an exhibition celebrating Brett Weston's work. Later next year, we'd like to exhibit Richard Misrach's work in conjunction with our publication of his book, *Violent Legacies*.

The Burden Gallery is not, however, a commercial gallery, though we have sometimes sold photographs. We've done that to support the photographers themselves, who put a great deal of effort into making the prints for the shows, and to help meet the overhead cost of the space. There has not been a financial gain over expenses at any time.

RA: What is the Stieglitz Center at the Philadelphia Museum of Art?

MEH: I founded the Alfred Stieglitz Center in 1968–69, at the generous and kind invitation of Dr. Evan H. Turner, who was the director, and with the encouragement of Dorothy Norman, who was providing support for the creation of the Center and had donated, or was donating, significant prints from her collection.

RA: Is the Center funding Aperture?

MEH: No.

RA: Many people conceive of Aperture as a major public institution, like a museum, and its record of accomplishment is so large that people naturally suppose it is financially well-off and stable. Aperture has, you've said, an endowment?

MEH: Paul Strand and his wife Hazel left to Aperture their life's work—his life's work. We were directed to sell a small portion of this to be able to get some of the most important works to major institutions. As you may know, Strand almost never sold the most important works of his career. We didn't even know that they existed when we did the Philadelphia Museum show in 1971. Many of them were discovered after his death. So it was our job to make sure that these prints were properly placed.

That resulted in income to the Foundation, and this income was placed in three funds. One is the Project and Operating Fund, in which two-thirds of the money goes to support projects. We had the belief, or hope, that money would come back and we'd be able to stabilize this fund. But what happened was that we supported a great many projects that were services to the field, as it were, and which nobody else would do. I think they were important. But the money never came back.

There is a small Building Fund, which was meant to provide a proper space for the Strand material.

And the third fund is the Endowment. This has been sorely taxed, in part by trying to maintain our offices in New York. If we continue operating as we are now—without substantial outside funding—Aperture will not exist in two or three years.

RA: I have heard that Aperture may be looking for new quarters. Is that so?

MEH: Shirley Burden, who was chairman of our board, felt that we needed to have a base in New York City, so he

acquired the 23rd Street building for us. He died about three years ago, and due to complications in his estate, the building was not donated to the Aperture Foundation, as we believe was his intention.

We simply don't have the kind of resources that make it possible for us to sustain, without outside support, a space like the one we are currently in. So we are trying to sell the building, and then we will try to get more modest quarters.

RA: To a better subject . . . why don't you speak a little about Paul and Hazel Strand, about who they were.

MEH: Paul was a loner; he kept to himself. He was a tenacious person, totally dedicated to what he was doing, and I think quite isolated in that way. He'd had fairly bad experiences over the years with museums and institutions, as Stieglitz had. So it was unusual for Paul to make a personal and professional connection with me in the sixties, at the introduction of Nancy Newhall. As a matter of fact, my first letter to him, which I still have a copy of, is quite naive, and perhaps much more enthusiastic than was appropriate.

I didn't understand Strand's work at all. I thought it was documentary or highly representational. I had no idea that he was working in a realm of abstraction, with an almost transcendental kind of imagery, and that if you had

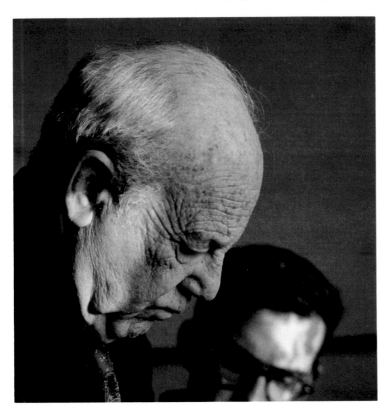

Paul Strand and Michael E. Hoffman considering the republication of the Mexican Portfolio, *Brooklyn, 1965*

been where he was, you would never have seen what he saw!

Strand was a magical figure, whose work grew and grew on me, a little like Wagner's, which I hated and detested as a child, and gained tremendous respect for as I grew older—not that I think Wagner and Strand are similar. Anyway, he responded to my letter by calling Nancy Newhall, or writing to her, and saying, "Who the hell is Michael Hoffman?" Nancy strongly recommended that we meet, which we did in 1965. And I committed myself to republishing the *Mexican Portfolio*. I felt with Paul there was incredible work to be accomplished, because he had been working for so many years, and so little had been done with these remarkable photographs.

In any event, Paul and I gained confidence in each other, and then he did something that he had never done with anyone else—he entrusted me with the direction of his work.

Hazel was Strand's third wife. She was a great partner, a great companion, and a person with a wonderful ability to deal with people. She could fit right into the environment and relate to people wherever she went, and it was a tremendous asset. She was also a photographer.

RA: The little book of pictures she took in Italy is very sweet.

MEH: Well, she documented everything they did. She had been the studio manager for Louise Dahl Wolf, the noted fashion photographer. Hazel had a broad sense of the arts, and was close to people like George Platt Lynes. She was a much more accepting person than Paul. Whereas Paul was homophobic, for example, Hazel would not have judged people by their sexual preferences. She had a great affection for and acceptance of a broad variety of people, and admired them for what and who they were. And I think eventually that rubbed off on Paul. He was a demanding individual, but a person of graciousness at the same time. He was very slow, where Hazel was quick

RA: In conversation?

MEH: Physically. He walked slowly. He was always observing. He was the most observant person I have ever seen. Everything mattered; he took everything in. He did not see himself as a twentieth-century photographer. He really felt connected to Piero della Francesca, and to other figures of that time. He saw himself as part of a continu-

um, a great tradition that he was trying to further. I think you can get that sense when you see an original print. Few people ever get to see an original Strand print close up. As soon as there is glass on it, as soon as there is only low-level lighting, which museums now require, you cannot see Strand's work. It has so many layers.

I developed a heartfelt admiration for both Paul and Hazel. At Paul's death he had basically set things up so that I would continue to take care of his work, and Hazel relied on me to protect it and continue access to it.

They didn't want it to go to an institution, where the work would be sequestered away. They didn't want it to be put in boxes and not dealt with. We've done a lot of things with the work that no institution would do. Most paper restorers wouldn't touch the prints. Well, we have not only touched them, we have revived them, cleaned them, brought them back to where they had been. The prints are as luminous as they were when they were made. Our archive director, Anthony Montoya, is a brilliant conservator, and a deeply caring person.

RA: When did Richard Benson start working with the Strands?

MEH: Richard is a remarkable man whom they agreed to let into their home to help in the darkroom. Paul had never allowed anybody in his darkroom in all those years. Once Richard was there, however, they didn't want him to leave—which I could understand, knowing Richard.

It was a very rewarding period near the end of Strand's life, due to the fact that Richard was there, and also because Paul worked up to two weeks before he died. For Strand, photography was alchemical. It was not a rational process. And Benson was able to bring to it a certain rational approach. Though I should also add that Richard's prints of Strand's work were never the same as Strand's. Richard agreed that there was no way to duplicate what Strand did that he could figure out. Strand's alchemical process gave a certain life to his prints that is unique in photography. Now we only use Paul's original negatives to make gravures or prints solely for purposes of study.

Hazel lived for six years after Paul died and devoted

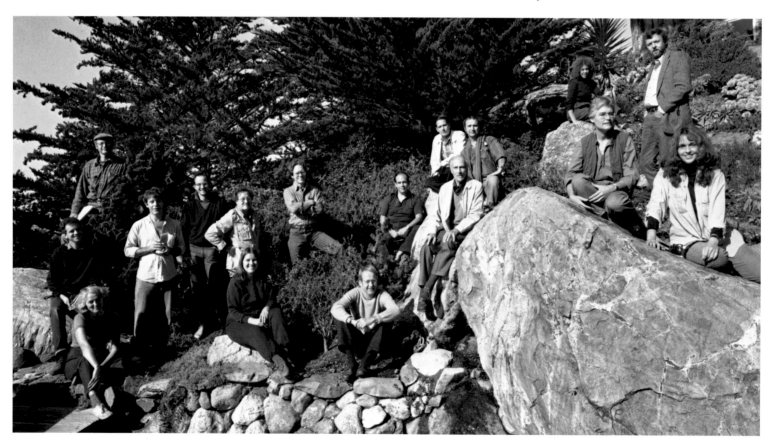

Participants of "Photography 1982," a symposium sponsored by Aperture at the Esalen Insitute, Big Sur, California; photograph by John Grimes. Symposium participants were: Robert Adams, Chris Beaver, Steve Beck, Martha Chahroudi, William Christenberry, Linda Connor, R. H. Cravens, Raymond Depardon, Raye Fleming, Brewster Ghiselin, Frank Gohlke, John Grimes, Siegfried Halus, Michael E. Hoffman, Mark Holborn, Judy Irving, Carole Kismaric, Alison Knowles, Jerome Liebling, Brian Lyke, Nancy Lunney, Carol Mersereau, Ray Metzker, Michael Murphy, William Nabors, Thomas Ockerse, Richard Price, Joyce Rogers, Ingrid Sischy, and Heather and Rick Tarnas

herself to completing the organization of the archive. She bought a house in Millerton. She was close to all of the people at Aperture. And she was, I think, quite unhappy and lonely at the end of her life. But she provided us with the ability to fulfill Paul's wish, and that was first of all to place his work in major institutions around the world, which has been accomplished.

The works were acquired in such a way that made for a very meaningful exchange. The money that Aperture received was used to help—and continues to help—many, many more photographers than the Strands could have imagined, because these funds were and are used to support numerous projects that we could not fund any other way.

RA: There is a passage in Buddhist literature that says of the dharma, "If you try to hear it with your ears, you'll never understand it. Only when you hear it through your eyes will you really know it." I am curious what photographers—you can limit your answer to the dead, if you want—have made photographs that are clearly audible to your eyes?

MEH: For work to be really alive to me, it has to engage with the world. I may talk about spiritual matters, I may talk about transcendental things. But to me, you don't have those qualities without engaging in heaven and hell, because you don't know one without the other. And I don't mean to get into a Calvinist dichotomy here, or even to suggest that I see things totally in terms of darkness and light. Not at all. It's only a metaphor for my concerns.

I think the greatest photographic work is that which has somehow engaged with the depths and the heights of the possibilities of our experience. Although Stieglitz was not socially aware, he was able to accomplish work with great emotional depth, intellectual reach, and sensory awareness. Strand, on the other hand, dealt with a wide range of subject matters. And Minor engaged the Furies.

I find that work which doesn't do this, and isn't guided by a certain grace or graciousness toward the world, tends not to be sustaining. I really don't like work where there is a strong, self-conscious attempt to create Art.

It's very similar to what James Baldwin said in *Notes of a Native Son*, that sentimentality is the most sadistic of human emotions. For me, what he meant was, sentimentality divorces one from the real qualities of experience. And I think that we have a danger of this separation in photography, where for mercenary reasons, for reasons of trying to please curators in museums or whatever, people sometimes do work that ends up being contrived and divorced from substance.

RA: I know you admire Dante. Who are the other authors who have remained with you as guides?

MEH: Well, I think of Melville, because with him you have a titanic struggle between inner human forces and the outer forces of the world. In the case of Captain Ahab and the whale, I can't help feeling a certain understanding and sympathy.

But I go back to Dante, because he seems to offer a key in the search from darkness to light. And also, although I have never been able to study them as I would like to, the great Indian literatures of the Vedas and the Upanishads, and the *Mahabharata*. The *Bhagavad-Gita* is a primary tool for anybody who is trying to live a life out of the ordinary.

RA: Do you read other photo periodicals?

MEH: I have to tell you that I leave that to the staff, although *Afterimage*, which I haven't seen in quite some time, is a valuable publication. It's informative. It's noncommercial. I don't know that it always holds up. It can be very subjective. But I always think of it with great fondness as an important publication. And the new editors at *American Photo* have tried hard to have a broader reach.

RA: Do you read art magazines—*Artnews, Art in America*?

WE HAVE NOTHING TO LOSE BUT OUR PHOTOGRAPHY

Ansel Adams

The first issue of Aperture, *1952, inside cover*

MEH: We have been most closely linked with *Artforum* because of staff connections—Chuck Hagen and Melissa Harris. Ingrid Sischy, who I think is brilliant—although I don't always agree with her—was just about to become the editor of *Aperture* when she took the job at *Artforum*. She would have been extremely interesting to work with. Now she's the editor of *Interview* and writes about photography for the *New Yorker*.

RA: The past few years have seen Aperture's financial position remain relatively weak, like that of many other

I think the greatest photographic work is that which has somehow engaged with the depths and the heights of the possibilities of our experience.

worthwhile organizations. In one of the early issues of the magazine Minor White wrote, "Is wide acclaim necessary to the pursuit of unpopular photography? No! A little radiance here and there is enough."

MEH: I remember that.

RA: It's a wonderful sentiment. But is it really enough? Or has the whole effort become more desperate in some way since his time?

MEH: The odds have increased, because now there is so much interest in photography. There is so much material taking up people's attention that it's much more difficult for things of real quality to get through. There is tremendous confusion over what is meaningful and what isn't.

RA: *Aperture* has over the years had a number of friendly competitors. *Picture* magazine, for example, and *Untitled*—periodicals that have set out, like *Aperture*, to do a responsible job with important photography. Why do you think *Aperture* has lasted?

MEH: Well, first of all, I have never viewed those publications as competition.

RA: No, they're not. They've been allies.

MEH: Yes, I feel that. I think that these are important publications. The one problem with *Untitled* is that it has tended to be fairly traditional. You know what happens when you look backwards too much. You get turned into a pillar of salt. And *Untitled* suffers oftentimes from a fairly conservative viewpoint, from not taking those leaps into the darkness. I think in order to be relevant and to

sustain oneself, one has to be willing to take those risks constantly. Because otherwise, what does one have to provide to people? You're not of any use if you're just offering people what they already know.

So I suspect that *Aperture* has continued, at least for now, because some people feel they are getting something they can't get any other way.

RA: As you look back over your tenure with the magazine, by what issues do you want most to be judged? What are the ones that you're happiest about?

MEH: I'm fond of presenting work that is not widely seen. Some of the monographs were a way to do that. I enjoyed very much working on the Josef Sudek book. I can't say I enjoyed working with Gene Smith, because it was very painful, but I think it was terribly important. There were no books on Gene when that monograph was published in the sixties.

In general I think the issues that interest me most are the ones that are most recent. I tend not to want to look back very much. I do love the early issues Minor did, because they remind me of his wonderful qualities, and the way he worked. I love the things Nancy Newhall did. I miss her very much. But I think what we live for are the new things.

RA: If you could afford a half-dozen photographic prints from any time period to place in the editorial offices, what would those be? What pictures would suggest the responsibilities and consolations to which Aperture is committed?

MEH: The best thing would be if we could show the work that came in yesterday, and keep that up in front of us for a while and then move on.

When Minor and I edited issues, we always laid the pictures out and insisted on watching them, living with them for a period of time. Minor edited the magazine, when he did it, in his own home. And this was an important process.

So if you ask me what I would put up in the editorial offices, I would put up the most recent dynamic pictures and allow people to live with them and see what happens. Because people's perceptions evolve and change, and pictures have effects that are different in the morning and in the evening.... And then I'd change the pictures. I would not want to put up any one particular symbolic image or group of images to represent what is important in photography.

BARBARA MORGAN
"Touched with light"

Barbara Morgan, a remarkable pioneer in photography and one of the founders of Aperture, *died on August 17, 1992, at the age of ninety-two. Although most celebrated for her extraordinary studies of modern dance in the late 1920s and early '30s, her entire artistic career was fluid, searching, and widely embracing.*

As a student at UCLA, she was introduced to Arthur Wesley Dow's principles of art "synthesis," in which abstract design paralleled realism in drawing and painting. Reading from the Chinese Six Canons of Painting taught her the concept of "rhythmic vitality" — an idea she was to explore all her life. After graduating she joined the UCLA art faculty, teaching beginning landscape and woodcut, as well as basic design.

Photography came by way of "daily osmosis" from her husband, writer and photographer Willard Morgan. She continued to paint and make woodcuts and lithographs in New York City, until, upon the birth of Lloyd, her second son, she turned her full creativity to photographing. Never static, she searched for balance and harmony between family life and work. In 1941 she moved from Manhattan to Scarsdale, New York, where she maintained the studio in which she photographed such luminaries as Martha Graham, Merce Cunningham, José Limón and Pearl Primus, as well as providing for her children "fresh air, trees, animals to care for."

She remained true to her love of experimentation and artistic exploration, producing important work in photomontage and moving light designs. Among her many accomplishments are her books, Martha Graham: Sixteen Dances in Photographs *and* Summer's Children: A Photographic Cycle of Life at Camp, *as well as numerous articles and exhibitions of photographs, paintings, and graphics. Her 1964* Aperture *monograph was edited by Minor White, who wrote:*

"Of several reasons why Barbara Morgan was requested to design, write and produce the publication of a monograph about her own work, one reason is that she is experienced enough to do it. How wonderful to behold a person who has developed all of these capacities because of her practice of living as a whole being.... It is our pleasure to extend our deep feelings of gratitude to Barbara Morgan for her contributions to Aperture."

Her life and work are a continuing celebration.

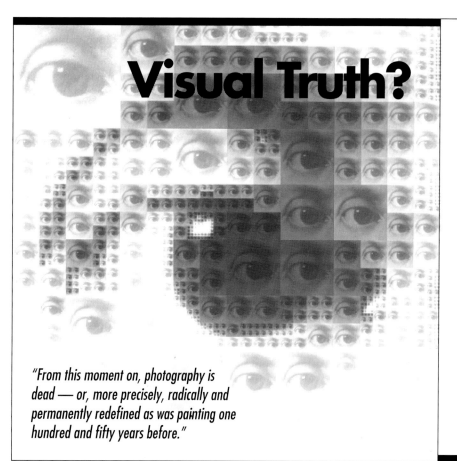

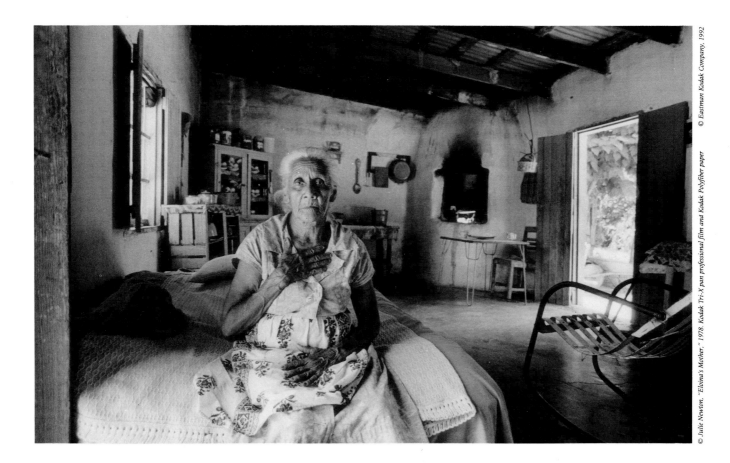

The light through the doorway pressed gently
on her face,
showing me her world, her house, her bed,
her eyes.
She looked into my eyes through the camera,
as if she knew she would be looking at the world,
and without fear.
She always cried when I showed her a picture
of herself.
Eloina told me later her mother was unhappy with
how she looked,
old and wrinkled.
"Julie's camera never lies," Eloina said.
I never thought of her as old and wrinkled.
I saw a woman, a friend.
And she always asked me to take another picture.

—Julie Newton

Julie Newton is a photographer in Austin, Texas, and a faculty member at the University of Texas at Austin.

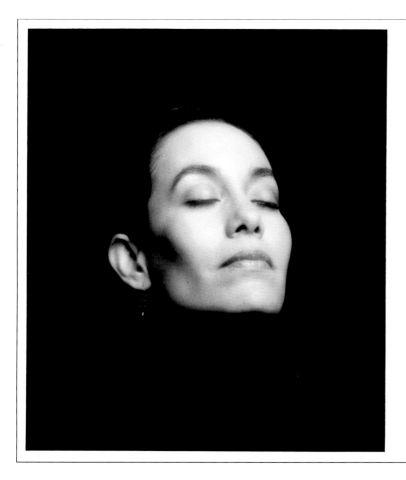

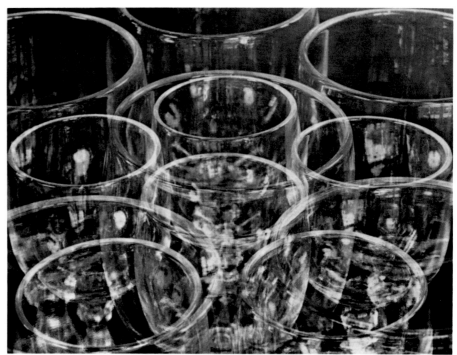

FLOR GARDUÑO: *CANASTA DE LUZ*, 1989, GELATIN SILVER PRINT

MARIO CRAVO NETO: *ODÉ*, 1989, GELATIN SILVER PRINT

VISION GALLERY

FINE VINTAGE AND CONTEMPORARY PHOTOGRAPHS

1155 MISSION STREET, SAN FRANCISCO, CA 94103

415-621-2107

Frida Kahlo and Diego Rivera, Mexico, 1934

Photographs by Martin Munkacsi
December 10 - January 9, 1993

HOWARD GREENBERG GALLERY

Fine Vintage & Contemporary Photographs

Exclusively representing

Anton Bruehl	Ralph Eugene Meatyard
Arnold Eagle	Martin Munkacsi
Eikoh Hosoe	Dorothy Norman
William Klein	Arthur Rothstein
Leon Levinstein	Roman Vishniac

And collections including

Berenice Abbott	Lewis Hine
Imogen Cunningham	Jacob Riis
Frantisek Drtikol	W. Eugene Smith
Walker Evans	Alfred Stieglitz
Robert Frank	Josef Sudek

120 WOOSTER STREET NEW YORK 10012
TEL 212 334 0010 FAX 212 941 7479

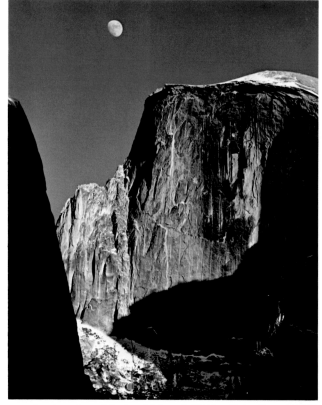

LISETTE MODEL
Twelve Photographs

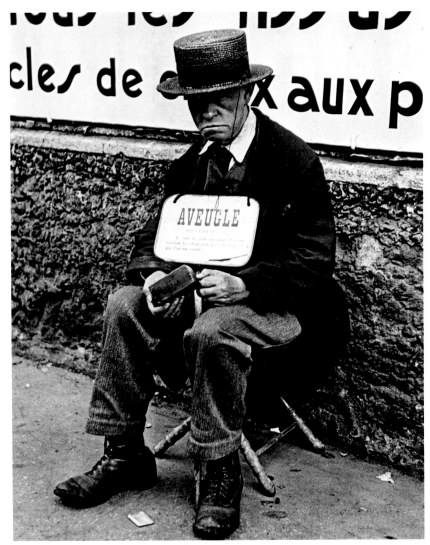

Blind Man in Front of Billboard, Paris, 1933–38, gelatin silver print, 20 x 16 inches

A PORTFOLIO PUBLISHED IN 1976 BY LUNN GALLERY
IN AN EDITION OF 75. $11,000.

LUNN LTD.

237 LAFAYETTE STREET NEW YORK NY 10012 ■ (212) 966-5781 ■ FAX (212) 966-5648

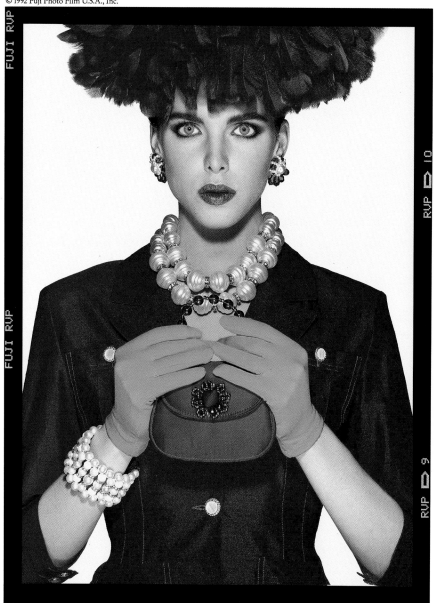

Your work can live, or die, in the blink of a shutter. If you prefer the former, we suggest Fujichrome Velvia.

Velvia's brilliant color and ultrafine grain are

MARCO GLAVIANO HAS BEEN SHOOTING FUJICHROME VELVIA SINCE 1990.

unequaled in ISO 50 film. And so is its resolution; a fineness that brings out the best in fabrics, textures and skin tones as well. Velvia is also proven to sustain neutral tones, from bright high-lights to deep shadows, while still managing to maintain highly detailed, super-saturated blacks. Velvia also has something to offer even the most jaded pragmatist: E-6 processing. In a world of super models and radical fashions, there's finally a film that lives up to the adjectives. To hear more, call 1-800-659-3854, extension 2571.

TO DEVELOP A LOOK THIS BEAUTIFUL REQUIRES TWO HOURS OF MAKE-UP, THREE HOURS OF HAIR, A DAY OF STYLING, AND 1/500TH-OF-A-SECOND OF VELVIA FILM.

FUJI. A new way of seeing things.

NUMBER ONE HUNDRED TWENTY-NINE

FALL 1992

The editor for this issue is Melissa Harris; assistant editor, Lynne Honickman.

Front cover: Robert Rauschenberg, *Horse Silk (Night Sights Series)*, 1992. Vegetable dye water transfer on paper, 41 7/8" × 35".

Composition by The Sarabande Press. Duotone separations by Robert Hennessey. Printed and bound by Everbest Printing Co., Ltd, Hong Kong.

Aperture (ISSN 0003-6420) is published quarterly, in February, May, August, and November, at 20 East 23rd Street, New York, New York 10010. A one-year subscription (four issues) is $40 and a two-year subscription (eight issues) is $66. Second Class Postage is paid at New York and additional offices. Postmaster: Send address changes to Aperture, P.O. Box 6678, Syracuse, NY 13217. A subscription for four issues outside the United States is $44. Address queries regarding subscriptions, renewals, or gifts to: Aperture Subscription Service, 1-800-825-0061. Single copies may be purchased for $18.50 for most issues.

Editorial contributions must be accompanied by return postage and will be handled with reasonable care; however, the publisher assumes no responsibility for return or safety of unsolicited artwork, photographs, dummies, or manuscripts.

When photographs or art submissions are requested by the publisher, any value for which Aperture could be liable must be agreed upon in writing in advance of delivery. If no agreement in writing is in effect, Aperture will not accept responsibility for the care or safety of material in its possession.

ISBN 0-89381-535-7
Trade Edition ISBN 0-89381-522-5
Library of Congress Catalog Card No.: 5830845

Statement of Ownership, Management, and Circulation (Required by 39 U.S.C. 3685). 1A. Title of publication: Aperture; 1B. Publication no.: 687250; 2. Date of filing: September 30, 1992; 3. Frequency of issue: Quarterly; 3A. No. of issues published annually: 4; 3B. Annual subscription price: $40.00; 4. Complete mailing address of known office of publication: 20 East 23rd Street, New York, N.Y. 10010; 5. Complete mailing address of the headquarters of general business offices of the publisher: 20 East 23rd Street, New York, N.Y. 10010; 6. Full names and complete mailing address of publisher, editor, and managing editor: Publisher: Michael E. Hoffman, 20 East 23rd Street, New York, N.Y. 10010 and Elm Avenue, Millerton, N.Y. 12546; Editor: Melissa Harris, 20 East 23rd Street, New York, N.Y. 10010; Managing Editor: Michael Sand, 20 East 23rd Street, New York, N.Y. 10010; 7. Owner: Aperture Foundation, Inc., 20 East 23rd Street, New York, N.Y. 10010; Non-profit Corporation; there are no stockholders; 8. Known Bondholders, Mortgagees, and other security holders owning or holding 1 percent or more of total amount of bonds, mortgages, or other securities: None; 9. For completion by nonprofit organizations authorized to mail at special rates: The purpose, function, and nonprofit status of this organization and the tax exempt status for Federal income tax purposes (1) has not changed during preceding 12 months; 10. Extent and nature of circulation (Average no. copies each issue during preceding 12 months; Actual no. copies of single issue published nearest to filing date): A. Total no. copies (net press run): 18,925; 17,000; B. Paid and/or requested circulation: 1. Sales through dealers and carriers, street vendors, and counter sales: 736; 200; 2. Mail subscription (Paid and/or requested): 15,171; 14,011; C. Total paid and/or requested circulation: 15,907; 14,211; D. Free distribution by mail, carrier, or other means, samples, complimentary, and other free copies: 50; 0; E. Total distribution (sum of C and D): 15,957; 14,211; F. Copies not distributed: 1.) Office use, left over, unaccounted, spoiled after printing: 2,928; 2,789; 2. Return from News Agents: 40; 0; G. Total (Sum of E, F1, and F2): 18,925; 17,000. I certify that the statements made by me above are correct and complete. Signature and title of Editor, Publisher, Business Manager, or Owner: Michael E. Hoffman, Publisher.